# Migrations

# MIGRATIONS

## NEW DIRECTIONS IN

## NATIVE AMERICAN ART

### EDITED BY MARJORIE DEVON

University of New Mexico Press

Albuquerque

DESIGN AND COMPOSITION: *Mina Yamashita*

Library of Congress Cataloging-in-Publication Data

Devon, Marjorie.

Migrations : new directions in Native American art / Marjorie L. Devon.

p. cm.

Published in conjunction with an exhibition at the University of New Mexico Art Museum in Sept. 2006.

Includes bibliographical references.

ISBN-13: 978-0-8263-3769-6 (pbk. : alk. paper)

ISBN-10: 0-8263-3769-4 (pbk. : alk. paper)

1. Indian prints—United States.

2. Prints, American—21st century.

I. Title: New Directions in Native American Art.

II. University of New Mexico. Art Museum.

III. Tamarind Institute.

IV. Title.

NE539.3.A4D48 2006

769.973'08997—dc22

2006003034

To the Native peoples of North America,

who have much to teach us about respect

for the land and our communities.

# Contents

# Preface

Since 1970, the University of New Mexico Art Museum and Tamarind Institute have been partners in the preservation of the art of lithography in the United States—Tamarind as an active workshop for the training of career master printers in the art of lithography and a coveted destination to which professionals from around the world come to create art, and the UNM Art Museum as the repository for Tamarind impressions. This beneficial relationship has prospered and grown; the museum currently holds over six thousand Tamarind lithographs in the Tamarind Collection and regularly collaborates with Tamarind Institute to present such prestigious traveling exhibitions as *Tamarind at Forty* and *Multiple Impressions: Native Americans and the Print*.

It is with great pleasure that we join with Tamarind to create an exhibition showcasing this most recent of their many innovative projects. A project begun in 2002, *Migrations* exemplifies three goals shared by the UNM Art Museum and Tamarind Institute—presenting the work of outstanding Native American artists working with a contemporary vocabulary, broadening the understanding of contemporary Native American art, and encouraging serious discourse related to Native American artists. *Migrations* features the prints of six outstanding Native American artists who worked with master printers at Crow's Shadow Institute of the Arts, in Oregon, and Tamarind Institute, as well as their work created independently in a number of mediums. The UNM Art Museum is honored to be the institution originating the exhibition this publication accompanies, and to present these emerging Native American artists. ↜

—Linda Weldy Bahm, Director,
University of New Mexico Art Museum

# Acknowledgments

We greatly appreciate the opportunity to do the *Migrations* project, which has enriched our lives in countless ways, and extend our heartfelt gratitude to all those who made it possible: the artists, for their talent and creativity; our funders, The Andy Warhol Foundation for the Visual Arts (particularly Pamela Clapp) and the National Endowment for the Arts (particularly Visual Arts Director Robert Frankel of Museums and Visual Arts and Visual Arts Specialist Wendy Clark); Crow's Shadow Institute of the Arts and their tireless printer, Frank Janzen; Tamarind's superstar printers Bill Lagattuta, Deborah Chaney, and James Teskey; the selection panel, including Deborah Wye, Siri Engberg, Jaune Quick-to-See Smith, and Truman Lowe for generously giving us their time and attention; authors Kathleen Howe, Lucy Lippard, Gerald McMaster, and Jo Ortel, who endured my endless pestering; the University of New Mexico Press (especially my editor, David Holtby) for having their priorities in the right place; the University of New Mexico Art Museum (particularly Kathleen Howe, previously curator of Prints and Photographs, curator of Exhibitions, Lee Savary, and Director Linda Bahm) for organizing and hosting the exhibition; TREX, particularly Mimi Roberts for her relentless "can-do" attitude and detail-man extraordinaire, David Gabel; and to the terrific Tamarind staff, for their ideas and enthusiasm, for their extraordinary ideals and dedication. ⁓

# Introduction

A few months ago, I was honored to share a stage with Jaune Quick-to-See Smith, an artist of French Cree and Shoshone descent whom I have known (and admired) since 1978. I can still hear her voice, its fast-paced, rhythmic monotone, reminding us all:

Culture is our identity.

It makes us different one from another.

Culture is our history, yours and mine.

Culture tells who we are.

Robots and computers will never have it.

If you take your Soma Pill you won't have it either.

Culture can be our creation myth—

Did Coyote capture the sun

Or did a voice say, Let there be light?

Culture is our creation story—

Did God on high create the humans first and make them most important

Or did the Creator place the animals, the land and the humans

in a holistic world.

Culture is our birthing method,

Do we sit up,

Lay down

Or do we squat.

Culture can be the way we greet the newborn child—

Is it washed in mother's urine

Or held to the morning sun

Or slapped on the back.

Culture is your umbilical cord—

Do you bury it,

Carry it—

Or throw it away.

Culture can be our notion of beauty—

Is it the tattoo on our chin

Or the red clay in our hair

Or walking with spiked sticks under our heels.

Culture can be the way we bury our dead—

Do we push a raft into the river

Or make a stone pillar above the ground

Or sprinkle ash from a plane.

Culture defines the way we teach our children—

Through stories about the plants, animals, and the earth

Or through stories about *Star Wars*, Spiderman, *Dragonball Z*

Or *SpongeBob SquarePants*

Culture defines the way we dance—

In a lambada, the fancy dance, a waltz

Or square dance, break-dance, or the grind.

Culture is how we greet one another—

Do we kiss cheeks, give handshakes

Or high fives, bow, or rub noses.

Culture is language, slang, humor, gestures, dance, religion, ceremony,

clothing, music, art, folkways, taboos, literature, foods, oral history,

institutions, systems, governments, and more.

Your culture, your identity, yours and mine. ⮌

Jaune's colorful description of culture triggers thoughts about the artists included in the *Migrations* project and how deeply connected their identity is to their culture, whether or not they grew up on the reservation. They, like all of us, are defined by the multiple influences in their environments, which together paint a composite image of an individual's identity. Each of the *Migrations* artists has experienced the fluid boundaries of culture, and their work embraces both the modern and the traditional. In fact, we selected the title, *Migrations: New Directions in Native American Art*, for its diverse implications of movement: between one time and another, between cultures, between places, between artistic mediums, between obscurity and the limelight.

The impetus for *Migrations: New Directions in Native American Art* was rooted in Tamarind's decades-long commitment to working with artists from varied backgrounds who have infused our programs with energy and curiosity. More directly, it grew out of a weekend seminar I attended at Crow's Shadow Institute of the Arts called "Conduit to the Mainstream." A grant from Art 21 and the Allen Foundation supported a gathering of arts professionals brought together to discuss how Crow's Shadow could facilitate the integration of Native artists into the structure of the art-world-at-large.

I came away from that weekend thinking about how we could develop a project that would address the issues that were raised at the seminar. How could we expose young Native artists to new situations that would stimulate their creativity? How could we showcase the talent of lesser-known artists? How could we attract broader recognition of and critical attention to their work? The Tamarind staff enthusiastically embraced the idea and helped shape the overall concept: we proposed to select "emerging" artists who would make prints either at Tamarind or Crow's Shadow and to include their lithographs, together with their work in other mediums, in an exhibition that would travel. Reaching a wide audience would help to dispel generalizations about the style and content of "Indian art." Documentation would be critical as well, to give the artists broader and longer-term exposure.

While a handful of artists of Native descent have achieved national and international recognition, Indian artists have been largely ignored by the power brokers of the art world. We hoped to identify lesser-known artists and offer a sampling of work by artists—not "Native artists"—who engage in

contemporary dialogue in a meaningful way. Fortunately, we found many willing partners, who enabled us to develop a multifaceted program that would address each of the goals we had in mind.

We began with a call for nominations—after considerable consultation and discussion, we required tribal registration and loosely defined "emerging" as not having had a major museum exhibition. Although we tried through a number of different channels to reach as many potential participants as possible, it was, by definition, difficult to find the "unconnected" artists. A panel of bright, perceptive, and generous arts professionals joined me in Albuquerque to select the six participants. Deborah Wye, chief curator of Prints and Illustrated Books, Museum of Modern Art, New York; Siri Engberg, curator of Contemporary Art, Walker Art Center; Jaune Quick-to-See Smith, artist and independent curator; and Truman Lowe, artist, professor, curator of Contemporary Art, National Museum of the American Indian, patiently reviewed hundreds of slides and selected work that intentionally represented a range of stylistic approaches, tribal affiliations, and media: Steven Deo (Creek/Euchee), Tom Jones (Ho-Chunk), Larry McNeil (Tlingit/Nisga'a), Ryan Lee Smith

(Cherokee), Star Wallowing Bull (Chippewa, White Earth Reservation), and Marie Watt (Seneca).

Working in collaboration—in the broadest sense of the word—is not an unknown concept for Native peoples accustomed to cooperating in a community, and the artists readily adapted to working with a master printer to realize their prints. Three artists made prints at Crow's Shadow, in collaboration with their Tamarind-trained master printer, Frank Janzen, while the other three worked with our printers at Tamarind Institute. Each artist spent several weeks in the print shop, where they created images on the stones and/or plates from which the editions were printed. The master printers facilitated the process for the artists, who were not trained in the technicalities of printmaking, guiding them with advice and technical assistance. Collaboration was, for each of the artists as well as for the workshop communities, a gratifying and stimulating experience.

Woven through all of the essays, as well as the lives of the artists, is the theme of community. Describing the development of "contemporary Native modernism," Lucy Lippard provides a context for the work of the six *Migrations* artists who all travel, she points out, "with cultural baggage," and work within a

complex set of expectations and realities, facing the challenge of escaping from stereotypes while remaining true to who they are and where they come from. Inclusiveness has long been a priority at Tamarind Institute, as Kathleen Howe demonstrates in her essay, "A Quiet Commitment: Tamarind and Native American Artists." Our "quiet commitment" turns up in projects such as *Migrations*, specifically designed to call attention to Native artists, as much as in our choice to publish the work of thoughtful, creative artists, some of whom just happen to be Native Americans. Crow's Shadow's strong community ties are explored in Gerald McMaster's piece, "Crow's Shadow: Art and Community." Jo Ortel turns her attention to the six artists included in *Migrations*, offering perceptive observations about the artists and their work. Their heritages surface boldly or subtly, in attitudes and imagery, in the work, which is universally honest and skillful—equal by any measure to work by artists not branded by a qualifying adjective. The last section provides biographical and exhibition details and lets the artists speak for themselves.

This book records only a few perspectives and represents just a small percentage of the many insightful and creative individuals who are writing and making art within and outside of Native communities. It is our intention for this book to accompany the exhibition rather than for it to serve as a catalog of the show. We have illustrated representative work by each artist and included reproductions of several pieces in the exhibition—ultimately, we wanted the freedom to include work completed in the intervening months between the manuscript deadline and the inauguration of the show at the University of New Mexico Art Museum in September 2006.

Artist Larry McNeil wrote, "In the Tlingit way of doing things, it is traditional to thank your audience for listening, because as we share knowledge, we share strength and life." In my culture, it is traditional to thank those who have given us a gift. So I thank all of those who have given us the gift of the *Migrations* project through their commitments— of funding, time, expertise, knowledge, and assistance; and I thank the audience for listening and looking. May we all hear clearly the voices that bring the gifts of knowledge, strength, and life—which, in turn, we hope will migrate into tolerance, understanding, and acceptance, not only in the world of art, but in the world-at-large. ⤸

—Marjorie Devon, Director,
Tamarind Institute

# PART ONE: Essays

*Whoever said that my paintings are not in traditional Indian style has poor knowledge of Indian art indeed. There is much more to Indian art than pretty, stylized pictures . . . Are we to be held back forever with one phase of Indian painting, with no right for individualism, dictated to as the Indian always has been, put on reservations and treated like a child, and only the White Man knows what is best for him? Now, even in Art, "you little child do what we think is best for you, nothing different." Well, I am not going to stand for it.*

—Oscar Howe, 1958,
on being rejected by the
Philbrook Museum's *Annual*
because his work was too modern
and abstract to be "Indian."

# Moving Days

*Lucy R. Lippard*

Things have been moving fast in the field of contemporary Native arts over the last ten years or so, and the artists themselves have been moving around too. As they migrate, their art becomes increasingly layered, like a rolling snowball that, unlike the proverbial stone, does gather new substance in its travels. The fractured geographies of those in global or national diaspora lead to broader and far more elusive definitions of what it means to be an "Indian artist." Yet the artists in *Migrations* are all traveling with cultural baggage. Each biography tells a sequentially place-specific story that has been modified by events beyond control, as well as by personal histories. Many of these stories are fueled by determination to survive. Sadness and anger at past and present may be mitigated by an inherited sense of time and space that is more expansive than conventional.

When I first became aware of "modernist Indian art," around twenty-five years ago, there were fewer participants in the burgeoning Indian art scene, and most of them seemed to know each other. Each new artist who emerged from reservation or art school was welcomed as a new strength for the team. Today the reservoir is much larger, and more disparate. There are as many Native North American art histories in this country alone as there are tribes—more than the 562 that are federally blessed. In each history, the adoption of, merger with, or adjustment to modernism varies again, depending on whether artists live on or off the reservation, whether they attended art school or not, and how close their tribal affiliations are, among other individual factors.[1]

Until the founding in 1962 of the Institute for American Indian Arts (IAIA) in Santa Fe, few Native young people attended art schools, especially outside of their own states. When they did, there was no context for their culturally grounded work except the literal and figurative glass cases in which Indian art had been imprisoned for over

a century. The IAIA, with its pan-Indian student body from the United States and Canada, offered not only an art education tailored to its multiple constituencies, but also introduced the budding artists to elder Native modernists like Oscar Howe (Yankton Sioux) and George Morrison (Chippewa), or satiric figurative painter Woody Crumbo (Potawatomi). Incoming IAIA students were taught by part-Luiseño Fritz Scholder, Chiricahua Apache Allan Houser, and Hopi Charles Loloma, among others, and then by their brilliant Kiowa/Caddo/Choctaw student, T. C. Cannon, who died prematurely in a car crash in 1978 at the age of thirty-two.

The IAIA was an updated successor to Dorothy Dunn's Studio School at the Santa Fe Indian School, founded in 1932 when Superintendent Chester E. Faris hired Dunn at the urging of fellow Quaker Olive Rush. From 1936 the director was Geronima Cruz Montoya of Jemez Pueblo. The Studio School promulgated a flat, "proto-modern" Pueblo-based painting style that continued as the dominant mode of contemporary Indian art through the 1950s, despite isolated figures innovating from the late nineteenth century on. The crucial difference between the Studio School and the IAIA is that the latter was founded and run by Native artists. This independence from white administration of Native aesthetics may be the best answer to the question: Where and when did contemporary Native "modernism" begin?

What, for that matter *is* contemporary Native modernism? As Janet Berlo and Ruth Phillips have concluded, it is not a style or conglomeration of derived styles. They identify the "modern" in Native art as defined "by the adoption of Western representational styles, genres and media in order to produce works that function as autonomous entities and that are intended to be experienced independently of community or ceremonial contexts."[2] That is the way I will use the term here, separating (but hopefully not ghettoizing) contemporary art by Native people from the usual Western modernism defined, for example, by art historian Norman Bryson: "A truly modern object is something like a Platonic form: it cannot be inflected by local ownership or idiosyncratic usage."[3] Native artists have ignored these restrictions. Native modernism is something else.

Oscar Howe's famous statement (which opens this essay) marks a milestone. Although others were working in this new territory, Howe kicked open the doors, or built a bridge, to a more widely accepted Indian modernism. He and then others pointed out

that the origins of their formal experiments were not in Western modernism but came from within their own "art histories," despite the fact that indigenous people have long been denied both "art" and "history," except those so designated by the dominant culture. The notion that "there is no word for art" in Native vocabularies has been overstated, although the blurring of lines between the "special" and the "ordinary" can be exemplary. "We may not have words for *art*," writes Tuscarora photographer Jolene Rickard, "but we do have words for the things we make."[4]

Native artists have crossed categories with impunity, bringing into the modernist vocabulary not only traditional metaphors and meanings translated into new forms, but also traditional mediums or "crafts" rejuvenated as "high art." For instance, half-Hopi weaver Ramona Sakiestewa's textiles have become increasingly unrecognizable as "Indian," even as she continues to participate in Native contexts, recently as a lead designer in the new National Museum of the American Indian in Washington DC. Cochiti potter Diego Romero paints his traditionally shaped vessels with the cartoonlike but never incompatible adventures of masked Pueblo alter egos cruising the contemporary world, just as Maidu Harry Fonseca's famous Coyote

series brought that ubiquitous trickster—"costumed" in blue jeans, shades, and sneakers—into the places where young Indians share (for better or worse) our national popular culture. As Coast Salish artist Lawrence Paul Yuxweluptun insists, "To deal with the contemporary problems that interest me I have to have a contemporary language."[5]

As for history, it is history whether or not it is written down by white people. Mi'kmaq video artist Mike MacDonald recalls, "I once heard an elder say that the great crime in this land was not that the natives had their language and culture beaten out of them in boarding schools—the great crime was that the people who came here did not adopt the culture of the land."[6] (Just imagine that!)

The identification of all modernism with Western art history has had various effects on contemporary Native artists. It has held some rebels in their traditional ways, refusing to trade in their culture for assimilation, holding out for "aesthetic sovereignty."[7] Although modernism and tradition are sometimes presented as incompatible, like art and politics, for many Native artists tradition is not the antithesis of modernism, but its mulch. On the other hand, the "traditional" (or the neotraditional) has become so romanticized and trivialized that some Native artists have

refused to make anything recognizable as "Indian art," taking refuge in the purported "universality" of high art. Commercial motives have inexorably played their part; "Indian art," so influenced by traders and external interpretation, is well defined in the minds of buyers looking for the "authentic" (and often falling for the inauthentic). Still other Native artists, including several in *Migrations*, have taken the stereotypes and run with them. Historical photographs by whites and the images of Indians as commercial logos or sports mascots have been used, and perhaps overused, by Native artists both beautifully and banally. Clichés like the "noble savage," the "Indian maiden," and the "nature-identified," "earth-wise" elder are paradoxically in danger of becoming new stereotypes as they are parodied within an inch of their lives in modernist contexts.

Western modernism, of course, does not break with tradition either; in fact, it often builds on the traditions of others, "new" only to white artists badly educated in world cultures. It is ironic, and insulting, that Indian abstractionists, especially those working from geometric heritages, were first perceived as "derivative" of better-known mainstream artists, some of whom had undoubtedly been influenced by their own external views of

Native art and "artifacts." Jackson Pollock, Barnett Newman, and Adolph Gottlieb were among the famous Abstract Expressionists who claimed inspiration from Native art. Yet as Apache anthropologist/art historian Nancy Mithlo has noted, "Never do we hear of a *named* Indian artist influencing a non-Native artist."[8] White artists who are inspired by (or ripping off) Native symbolism that they rarely understand are called "primitivists," leaving Indian artists, no matter how brilliant or avant-garde, as the "primitives."

Native abstractionists like Navajo Emmi Whitehorse (fig. 1) or Saulteaux Robert Houle, whose work stands up in any general arena, are always asked to explain their Native references. Since those references are there, they do so with grace, but it must be irritating that they are expected at all. Similarly, *Migrations* abstract artist Ryan Lee Smith, who was raised on the Cherokee Nation and intends to return there, says, "I want to show the art world that Native art is not solely about representations. There is a pulse or drumbeat that Native people have inside us. I want to translate that feeling in my work . . . I use white to paint out or maybe paint in the idealistic expectations of a good painting, much like the smallpox epidemic and measles-infested bedding our people were given out

of a false generosity, my paintings represent the removal of the ideal" (figs. 39, 40).[9]

↜

As a result of the radicalization of young Americans in the 1960s, during the next decade there were not only the occupation of Alcatraz (1969–71) and the explosive arrival of the American Indian Movement (AIM) at Wounded Knee (1973), but several major American museum shows of traditional Indian art, paving the way for modernists waiting in the wings.[10] "Pluralism" was a byword in the art world; interdisciplinary approaches began to break down other walls, paralleling feminist art and later the jargon-beleaguered diversity of "postmodernism." Traditional Native artworks were studied with greater respect and moved from the anthropological domain into art museums. There they were still treated as artifacts, though sometimes installed as art. Anishinabe Gerald Vizenor recalls a show of Ghost Dance shirts at the Minneapolis Art Institute in which the shirts, some riddled with bullet holes, were hung in a dimly lit room where they blew gently in the air, "animated in a very powerful way."[11] Vizenor was the first Native writer to be asked to contribute to a catalog

1.  Emmi Whitehorse
    *Pod*, 1997.
    Lithograph, 22 x 29⅜ in.
    Printed at Tamarind Institute by Karen Beckwith.

for an Indian art show, *American Indian Art: Form and Tradition* at the Minneapolis Art Institute in 1972.[12]

In the late 1970s, Native American modernist/contemporary art finally began to attract more attention outside of Indian communities and tourist towns. That is, it reached New York, and then Europe. Around 1980, the American Indian Community House Gallery, then in the heart of New York's SoHo gallery district, was directed by Seneca painter Peter Jemison (with assistance from Tuscarora photographer Jolene Rickard). They introduced the new Native art to the broader art public (educating me in the process). One of the figures who became nationally important to indigenous artists at this point was Salish/Flathead Jaune Quick-to-See Smith, raised on the Flathead Reservation in Montana, and living in Corrales, New Mexico, for many years. Smith, who had gone late to art school after raising her children and had just begun to show in New York, used Southwestern petroglyphs and other symbolic references within the fabric of a dynamic abstraction. As an independent curator and significant role model for younger Native women, she was a force to be reckoned with in her passionate dedication to finding and nurturing young artists from her own reservation and then, as she became better known and she traveled more, from all over the country.[13] Among others who were to be significant guides outside of IAIA were Ho-Chunk Truman Lowe, teaching at the University of Wisconsin in Madison and making his fluid wooden abstract sculptures that evoked natural forces (fig. 2), and Seneca/Tuscarora George Longfish who began teaching at UC Davis in 1973 while making expressionist paintings superimposed with words and symbols.

According to Mohawk artist Shelley Niro (fig. 3), "Until 1970, everything was so limited as far as the art [by Native Americans] that was out there . . . The whole culture started to change, things started happening and people started respecting things differently in the 1970s." Today, she says, writing in 2002, "I think we are in a vacuum that has to be filled and maybe once that vacuum gets filled, then we can be contemporary artists. Right now, it's just like everything is getting sucked up into that space [of "Indian" contemporary art] and I think it would be great if we were just considered artists. Maybe the next generation will be part of that contemporary art scene, where people want more than only one kind of Indian art."[14]

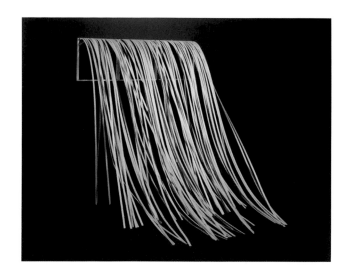

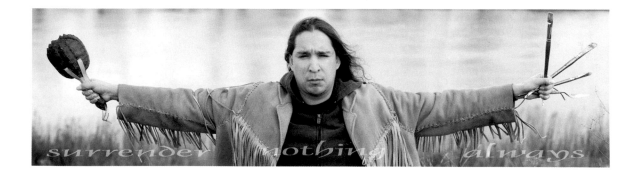

2. Truman Lowe
   *Waterfall*, 1993.
   Wood, 74 x 72 x 67 in.

3. Shelley Niro
   *Surrender Nothing Always*, 2004.
   Digitized photograph, 43 x 13 in.

The fact remains that there is a huge variety of Native art being made today and Niro is one of the contemporary trailblazers. After the close attention paid to specific cultures in the 1980s and 1990s (at the height of the multicultural "movement" in which the art world opened its gates to the exotic), the impetus today for many younger artists is simply, as Niro said, to be accepted as an artist among peers. At the same time, most are loath to abandon referential subject matter because it might be interpreted as a rejection of the culture itself. In 1998 Nancy Mithlo defined her generation as

> thirtysomethings who have enough confidence and training to openly question the mandates of an over-zealous market, but who find ourselves on a short rope when it comes to exposing the naiveté of our patrons lest we find ourselves abandoned by the only transportation left. Too old to be overly optimistic, too young to be crassly cynical, we tread boldly into uncharted territory without the protection that age may afford and lacking a certain stupidity that might have been charming ten years earlier. The choice to enter this

no-man's-land of questioning carries its own risks. Yet the alternative—mute victimhood—is much worse. The conspiracy, real or imagined, loses all its force once you bypass the roadblocks and chart your own path. Some artists never apprehend the journey, others embrace it.[15]

Nevertheless, by the early 1980s, we were beginning to see what Plains Cree artist, writer, and curator Gerald McMaster has called "fissures in the master narrative" that condemned Indians to the past and often to the "crafts" rather than "high art." McMaster has suggested that the mainstream was coming to an end and the "tributaries" would triumph.[16] But what we have actually seen since the 1990s is still a mainstream, with the addition of something like fish ladders, so that the strongest denizens of the dammed tributaries will survive. In a capitalist system, centers of power are inevitable. While tribal traditions stress reverential repetition altered over time very slowly and subtly, the mainstream fine art world still demands novelty. All contemporary Indian artists are aware of the delicate line they must tread between honoring traditions and at the same time making their own art distinguishable from

that of others. At the same time, the vaunted "originality" that sustained modernism for so many decades has given way to the splintered virtues of postmodernism.

At best, postmodernist approaches have fostered a disjunctive, nonevolutionary view of artistic "progress" that favors the recalcitrant inventiveness of Native artists. Many years ago, the great African writer Frantz Fanon wrote, "When a people undertakes an armed struggle or even a political struggle against a relentless colonialism, the significance of tradition changes."[17] A history of colonization and assimilation must be analyzed, used, and abused within these changing traditions. Comanche writer Paul Chaat Smith names the place where Native artists work today: "A space carved from hard lessons and bitter disappointment, a ruthless ambition for intellectual integrity and rejection of tired rhetoric, a passionate belief that our endlessly surprising communities are capable of anything, and a willingness to laugh, especially at the latest regulations from the Indian thought police."[18]

Much has been written over the last few decades about liminality, which comes from the Latin word for threshold, or the initial stage of a process. Activity is implied, along with some hesitation. The threshold leads somewhere—inside or outside; it is neither a stopping point, nor a waiting room. Those who have stepped over the threshold have entered a different space. In the late 1980s and 1990s, postmodernism's iconoclastic spirit coincided with a global wave of postcolonial theory that carried a number of artists from hitherto unconsidered cultures onto the shores (margins) of the art worlds. The concepts of hybridity, cross-culturalism, strategic essentialism, and other new ways of getting around the classic Eurocentricity of the modernist art world opened up new common grounds. Such cross-cultural negotiations, with parallel models in African, Asian, and Latino countries, have become the standard for younger artists acknowledging that indigeneity is an ideological space that can be worked in and on.[19] Aware that no single artist or style or subject can possibly "represent" Native America, they can reject the reduction of Native art to a simplistic spectacle of otherness. As Rickard put it, "I must theorize a space for myself as a Tuscarora artist in a culturally diverse world."[20]

One of the strategies that has become globally popular is to emphasize syncretism, the bringing together of different influences from different cultures within one's own. This has the effect not of watering down

specific cultures, but of demonstrating their complexity, serving to befuddle those who had memorized the "fictions of authenticity." The introduction of pop culture icons, for instance, like Mighty Mouse in Star Wallowing Bull's almost psychedelic autobiographical paintings, can refer to childhood memories shared by many. The mouse has his own hilarious Indian song that is a standard on Native radio programs.

"If the Other has no form, the One ceases to exist," writes African scholar Olu Oguibe.[21] This is not an argument to obliterate indigenous cultures, but to make them impossible to capture—a new take on the "vanishing Indian"; now you see her, now you don't. In the fissures through which these escapes are made, exciting new art is gestating. An interesting side effect is that with such a broad variety of contemporary art being produced, Native American specialists can seldom show off their expertise by pinpointing the artist's tribe of origin unless the artist wants them to. Contemporary art is not like traditional textiles and pots—recognizably rooted in place. Even the most thoroughly trained art historian or anthropologist is unlikely to be able to tell which tribe or region a modernist artist is from (and many are from more

than one). There is no stylistic index except that of individuals—uncategorizable. And those individuals may well want to subvert all historical expectations, deliberately misleading their critics before delivering the punch line: "Ha ha, I'm not Navajo, I'm Passamaquoddy!" "I just happen to have lived in Navajoland," or "I'm married to a Navajo man," or "I have a Navajo mother," "I admire Navajo arts . . ." Intermarriage and life choices (a Salish who has lived for many years in the Southwest, a Sac Fox teaching in Rhode Island, a Cheyenne working in South Africa, or whatever) have allowed many artists an array of "identities" with which to confound those who want to keep them in their place.

For instance, although it is often assumed that those who have been dislocated from their homelands are at a disadvantage, some of the most interesting art being made today is by those who are fully conscious of their separation as a modern condition. Larry McNeil, for instance, often offers himself up in his art as a "real Indian," spoofing the American thirst for "authenticity" while simultaneously showing pride in his Tlingit identity. While he lives far from the Killer Whale House in Klukwan, Alaska, and enjoys his Web site as a "democratic" manner

of distributing his work, he continues to see place as a crucial component in his art.

Native artists often work in a more complex context than the simple art school to gallery to museum trajectory. For many, community remains an important element even when the work doesn't fall into the external category of "community arts" (for example, murals, gardens, children's projects, etc.), and even when an artist's work may converge with the mainstream more and less often at times in her or his life. Contemporary artists continue to try to make art that will "read" in both their own communities and outside while maintaining aesthetic independence. (Luiseño performance artist James Luna says, "I do not speak for the community, I speak for myself, I speak for my vision and my interpretation of it.")[22] Steven Deo exemplifies the breadth of choices that can be made. A Creek/Euchee from Oklahoma, living in New Mexico, he works in whatever medium is best for what he wants to say, which may be a critique of US foreign policy (a fighting man made up of plastic toy soldiers), or a striking image of hands as healing stand-ins for the Twin Towers, or a man and boy fishing in the traditional way.

There continues to be a great deal of push and pull between those Native artists who have gone out into the world but want most of all to communicate with those at home, and the traditionalists, even the tribal councils, who often see change as a threat to already threatened artistic customs that play an important role in some tribal economies. Newly acquired Western egos can be seen as taking energy and talent away from the community. Some may distance themselves so as not to be criticized for selfishness when their careers take off. Others may try to become "Translator's children," to paraphrase what Joseph Bruchac has called "mixed bloods": "It means that you are able to understand the language of both sides, to help them understand each other."[23] Native societies have generally honored creativity; eventually pride seems to replace fear of exploitation. Artists like Luna, Rickard, Cheyenne Edgar Heap of Birds, and Navajo/Creek/Seminole Hulleah Tsinhnahjinnie, who have "made it" internationally, live or spend time on their reservations, participating in daily cultural and ceremonial life there as well as in the white world where their art is, ironically, sometimes better received.

Although the periphery may not always be a comfortable place, it is potentially a highly creative place. Gerald McMaster calls this place between reservation and urban

communities "Reservation X"—"a socially ambiguous zone, a site of articulation for the aboriginal contemporary artist that is frequently crossed, experienced, interrogated, and negotiated. This idea argues for a space of radical openness and 'hybridity,' or spaces of resistance being opened at the margins. I, however, see this space as in between two centers, which is a politically charged, though highly permeable, site."[24]

Typically, though not consistently, Native artists are also aware of the humor in their situation. In fact, wit, humor, and irony—often based in traditions even when presented in the framework of the avant-garde—play a greater role in Native art than in the mainstream, where art students are often taught to take themselves so seriously that they can lose sight of art's leavening spirit. When Tom Jones takes "America" (figs. 26, 27) as a starting point for a series of digital photo collages using turn-of-the-twentieth-century images of Indians, his bitter sense of the past is brought to us in a way that is both witty and poignant, forcing the viewers to learn that history anew. As a Ho-Chunk raised in Florida, Jones made "Indian" souvenirs for tourists while still in high school. He comes to the history in his images with a related past of his own.

Among the challenges facing the artists in *Migrations* is figuring out where the line should be drawn between an indigenous artist making modernist art and a modernist who happens to be indigenous making art. Once there began to be if not an abundance at least a sufficiency of contemporary Indian art shows in the later 1980s, culminating in some (but not as much as expected) attention in 1992, the banner year of Columbus's centenary, ambivalent younger artists became restless, hoping (as Niro said) that their success would allow them to be incorporated into "regular" art shows (and not just "multicultural" ones either). In the meantime, several artists who had been adopted out of their tribes and only discovered their Native bloodlines as adults moved in the other direction, welcoming inclusion in Indian shows and incorporating Indian subject matter into their art.

As the world gets increasingly complex, so do Native lives and arts. Artists like those in *Migrations* have many options. They can deny the aesthetic autonomy of modernism, its conventional separation from politics, activism, and real life. If they choose to make work that is not discernibly "Indian," they can still maintain the context in which they make art, and in that context lies their allegiance to their home places and peoples.

At some point it will seem increasingly less important to target only the dominant culture and increasingly challenging to make intricate criticisms from home bases. An apt metaphor might be offered by Marie Watt's *Vulnerable*—a column of blankets that might be prepared for sale, or for a giveaway. However, they cannot be separated from each other (they're attached by wires) even when the pile crumples and falls. Working collaboratively, with objects that bear their own histories of warmth and rejection, Watt has found a contemporary language in which to bring her Seneca culture home to wherever it is that we live. ✎

## Notes

1. Janet Berlo and Ruth Phillips's *Native North American Art* (New York: Oxford University Press, 1998) is the best overall history.

2. Ibid., 210, though I would amend this to "Western representational, abstract, and non-objective styles . . ."

3. Norman Bryson, quoted by Charlotte Townsend, "Let X = Audience," in *Reservation X: The Power of Place in Aboriginal Contemporary Art*, ed. Gerald McMaster (Ottawa: Goose Lane Editions and Canadian Museum of Civilization, 1998), 44.

4. Jolene Rickard, Ibid., 49.

5. Lawrence Paul Yuxweluptun, Ibid., 45.

6. Mike MacDonald, Ibid., 43.

7. I've examined this notion in "Aesthetic Sovereignty, or Going Places with Cultural Baggage," in *Path Breakers: The Eiteljorg Fellowship for Native American Fine Art, 2003* (Indianapolis, IN: Eiteljorg Museum and University of Washington Press, 2003), 1–10.

8. Nancy Mithlo, *Reservation X*, 57; my italics.

9. Ryan Lee Smith, from statements for *Migrations*.

10. In 1971 at the Whitney Museum of American Art; in 1972 at the Minneapolis Institute of Art; in 1976 Sacred Circles; in 1975 *Indian Art Magazine* began.

11. Gerald Vizenor, in conversation, December 2004.

12. Gerald Vizenor, "Tribal People and the Poetic Image: Visions of Eyes and Hands," in *American Indian Art: Form and Tradition*, exhibit catalog (Minneapolis, MN: Walker Art Center, Indian Art Association, and Minneapolis Institute of Art, 1972).

13. Smith began curating shows of Native art in 1977, when no other artist was taking on this responsibility. Among the important exhibitions she has organized are: the first Native American photography exhibition, 1984; *Photographing Ourselves*, which traveled across the country in 1985; *Women of Sweetgrass, Cedar and Sage* (with Harmony Hammond) for the American Indian Community House in New York, 1985; *Our Land/Ourselves* at the University Art Gallery, Albany N.Y., 1990; *The Submuloc Show/The Columbus Wohs* (traveling show for Atlatl), 1992.

14. Shelley Niro in Jill Sweet and Ian Berry, eds., *Staging the Indian: The Politics of Representation* (Saratoga Springs, NY: The Tang Teaching Museum and Art Gallery at Skidmore College, 2002), 82, 85.

15. Nancy Mithlo, "Conspiracy Theory," *Reservation X*, 135.

16. Gerald McMaster, "Towards an Aboriginal Art History," in *Native American Art in the Twentieth Century*, ed. Jackson Rushing III (New York: Routledge, 1999), 84.

17. Frantz Fanon, *The Wretched of the Earth* (London: Penguin Books), 180, 196.

18. Paul Chaat Smith, "The Meaning of Life," *Reservation X*, 40.

19. See Coco Fusco and Brian Wallis, eds., *Only Skin Deep: Changing Visions of the American Self* (New York: International Center for Photography, 2003).

20. Jolene Rickard, quoted by Townsend, *Reservation X*, 49.

21. Olu Oguibe, "In the Heart of Darkness" (1999), quoted by Eıy Camera, *A Fiction of Authenticity: Contemporary Africa Abroad* (St. Louis, MO: Contemporary Art Museum, 2003), 81.

22. James Luna, *Staging the Indian*, 75.

23. Joseph Bruchac, quoted in Lucy R. Lippard, *Mixed Blessings* (New York: Pantheon/New Press, 1990/2000), 175.

24. Gerald McMaster, "Living on Reservation X," *Reservation X*, 28.

# Crow's Shadow: Art and Community

*Gerald McMaster*

The now (in)famous sculpture *The End of the Trail* by James Earle Fraser (1876–1953) has become one of the most prevalent symbols of the American West. Some view it as a reverent memorial to a great and valiant people; many Native Americans, however, view it as a reminder of the defeat and subjugation they have experienced. This image of a dejected Indian figure on his weary horse, made by a non-Native artist, raises questions about the relationship between culture, identity, and imagery. It also underlines the importance of opportunities for Native American artists to shape their own images and reach new audiences within and outside of their communities. This is the story of Crow's Shadow Institute of the Arts and James Lavadour's ambitious vision to establish a community resource that would support Native art in all its dimensions.

The story unfolds in southeast Oregon, amidst invigorating and changing times on the Umatilla Reservation, where Lavadour

(Walla Walla) pursued his dream to extend a helping hand to Native artists. The Confederated Tribes of the Umatilla Indian Reservation include the Umatilla, Walla Walla, and Cayuse tribes; there are also many Nez Perce people on the reservation, although they are not recognized as a separate tribe of the confederation. In addition, some families count themselves as Métis, who originated in Canada and are referred to as "Alimas" ("mixed blood" in the local language). The three bands were brought together near Pendleton, Oregon, by a treaty with the US government in 1855. They, like all other tribes across the country, suffered heavy cultural, social, political, and economic loss during the latter half of the nineteenth and first half of the twentieth centuries. During the postwar period of the 1950s and 1960s, Native peoples across the continent, including the Umatillas, became more politically active and gradually began to recover their tribal identities and assert their sovereignty. The Umatilla affiliation developed its own

land use codes and established fishing rights but, by the 1970s, they were still struggling to preserve their tattered cultures and economic independence.

Lavadour was born and raised, and now lives and makes art, on the Umatilla Reservation. Early in his career he moved away, but he returned in 1975 to work as an artist in the tribal education program. The tribal administration was young, and most of the staff untrained, but serving the community was a high priority. Under the leadership of Education Director Woesha Hampson (Ho-Chunk), a Stanford graduate, Lavadour became involved with curriculum development. Although he had had no previous experience in the field, Lavadour quickly recognized that education of tribal members was key to the tribe's realization of its full potential. Like many people on the reservation, Lavadour had a strong social conscience and an idealistic commitment to community. Discarding the popular notion of the struggling, isolated artist, he hoped to use art to effect social change on the reservation. Lavadour's dedication and sensibility set the tone for the successful enterprise that Crow's Shadow would become.

Lavadour's contact with other Native artists through the Sacred Circle Gallery in Seattle, where he had been showing his own artwork, reinforced the idea of artistic community. He met established artists such as Kay WalkingStick, Edgar Heap of Birds, Marvin Lara, Truman Lowe, Frank La Pena, and Rick Bartow, who played important roles in their communities and had achieved significant recognition in the art world. For decades, successful Native artists in Canada and the United States have altruistically helped younger Native artists to succeed, generously sharing exhibition opportunities, resources, and key contacts. Lavadour was confident that a community-based art organization could attract resources and also be a conduit for Native artists into the mainstream art world.

The year 1989 was a watershed for Lavadour. Throughout the 1970s and 1980s he had continued to work for the tribe and to make his own art, and the end of the decade brought opportunities that changed his course: he was awarded a fellowship to make prints at The Rutgers Center for Innovative Print and Paper (affiliated with Rutgers University in New Brunswick, New Jersey); he received a major grant from the Seattle Arts Commission; and his ideas and experiences coalesced in the form of Crow's Shadow Institute of the Arts.

At Rutgers, a shop well known for its collaborations with artists representing diverse communities, he met Eileen Foti, a Tamarind-trained master printer. She, and others, introduced him to the print process, which gave him, as he said, "new conceptual tools" to apply to painting and life—to consider the future, and to plan ahead. His printmaking experience taught him the discipline that gave him the ability to forge ahead with his dreams.

That same year, Lavadour's vision became a reality: he leased a building, made some basic improvements, and established a nonprofit organization for artists. His painting called *Crow's Shadow* (fig. 4), which appeared in a major Portland exhibition, inspired the name of the institute. (Many people, no doubt, think that the name came from some mystical source. Not so. Crow was the name of Lavadour's dog.) *Crow's Shadow* was a pivotal piece in another sense too, as it marked Lavadour's decision to become a full-time artist.

Although it is not formally affiliated with the tribe, the institute is located on reservation land. Crow's Shadow is housed in a building that was once the reservation's primary school, St. Andrew's Mission (fig. 5). It had been vacant for years when it was

4.  James Lavadour
    *Crow's Shadow*, 1987.
    Oil on canvas, 48 x 34 in.

converted to artists' studios in the 1980s. La-vadour received a fellowship that gave him use of a studio for one year, and local artists rented the remaining studio spaces. When he was working with the tribe, James Lavadour had often taken his lunch break in the build-ing—and had frequently imagined how wonderful it would be if it could become an art school.

In 1992 Lavadour, with the assistance of another local artist, Phillip Minthorn, applied to and received a grant from the Bureau of Indian Affairs. They emphasized that the institute would be a reservation-based organization that would provide technical assistance to artists and, ultimately, serve as a conduit to the art world at large. Creating their own organization as a part of the community made them self-reliant; it was a means to provide a supportive environment for new experiences and, at the same time, a vehicle to broaden outside contacts. The tribe hired a development specialist to help Lavadour write a mission statement and organizational plan and to oversee an extensive renovation of the schoolhouse. Crow's Shadow Institute of the Arts was established as a nonprofit corporation with a board of directors, an executive director, and a grant writer. With grants that amounted

5. Crow's Shadow Institute of the Arts, Pendleton, Oregon.

to more than $300,000, they remodeled the building, purchased a press, and started programming. They initiated programs for youth and invited outside artists to work with them. To encourage social and economic development, Crow's Shadow also offered workshops on topics such as art marketing. Crow's Shadow became a focal point of activity for the community.

Crow's Shadow continues to provide educational, social, and economic opportunities for Native Americans through the arts. The institute promotes education as a fundamental value and emphasizes to tribal youth the importance of learning as the key to future success. Social opportunities grow out of a culture of working and learning together. A state-of-the-art facility, including a large printmaking studio (known as Crow's Shadow Press), computer graphics lab, photography darkroom, library, and studio space, brings technology, instruction, and cultural exchange to artists on the reservation. Crow's Shadow is committed to helping regional tribes revive and promote traditional Plateau arts within the Native community as well as to providing a forum for contemporary art.

Local audiences enjoy access to the arts not provided in any other venue. Exhibitions and public presentations offer exposure to stylistically diverse works, while open studios and workshops in a variety of mediums attract local youth to the institute for hands-on activities. Basket twining has been one of the most popular workshops, thanks to local master weavers Joey Lavadour (Walla Walla) and Pat Courtney Gold (Wasco), who have trained more than seventy-five people in the art. A new multifaceted project imaginatively combines the old and the new, bringing youngsters together with their elders to gather and process raw materials that will also be used for basketry and papermaking. Then the paper will be used for printmaking to expand the project in yet another direction.

Working with artists from other states and countries, it didn't take the fledgling institute long to build a national reputation.

A large, mixed-media piece hangs in the Crow's Shadow gallery today (fig. 6), reminding visitors of one of their most successful art projects. Fourteen teenagers from tribes around the Northwest worked at Crow's Shadow with Tim Rollins + K.O.S (Kids of Survival), well known for his collaborations with troubled youth from New York's South Bronx area that combine literature and art. They spent the first week studying Shakespeare's *A Midsummer Night's Dream*. The second week was devoted to

art: the group glued the bard's text directly onto canvas, then created individual inkblot "flowers" and collaged them to the canvas. Unique beads handmade by the kids literally added another dimension. The influence of Tim Rollins + K.O.S. will undoubtedly be felt for many years.

Printmaking activities have been the vehicle for several multicultural collaborations. Master Printer Eileen Foti, of Rutger's Center for Innovative Print and Paper, was closely involved with Crow's Shadow's programs for its first ten years. She helped them establish and equip the print shop and traveled to Oregon to teach workshops and collaborate with artists on many occasions. Aware of similarities in symbolism between cultures, Foti organized, in cooperation with Artist Proof Studio in Johannesburg, South Africa, *The Myth of Creation*, a portfolio project that brought together the work of community artists in Johannesburg, South Africa, San artists from the Kalahari Desert in Botswana, and Native youth at Crow's Shadow. The exchange called attention to relationships between disparate groups with common interests and was an unforgettable experience for all the participants.

Another print exchange, *Stories of the Living Land*, was a collaborative effort

6. In 2000 fourteen Native teenagers collaborated with artist Tim Rollins to create *Midsummer Night's Dream IX*. Collage and mixed media on canvas, 42 x 48 in.

between Crow's Shadow, the Institute of American Indian Arts in Santa Fe, New Mexico, and Western Sydney Institute, in Australia, which involved thirty-seven young Aboriginal artists from the three institutions, many of high school age. Initiated in Australia, the intent was to explore similarities and differences between the groups' ideas and beliefs. Judging by the huge contingent of tribal members who showed up for the opening, the project appealed to the local audience. The prints will be shown at the other institutions as well, giving all of the young artists welcome international exposure.

An important symposium, Conduit to the Mainstream funded by Art 21 and the Allen Foundation, gave Crow's Shadow invaluable exposure and credibility. A group of highly successful Native artists came together on the reservation with board members and arts professionals from around the country. Extensive discussions over a three-day period addressed both philosophical and practical matters related to Native art and artists.

Finding it difficult to sustain the printmaking programs without a full-time master printer, Crow's Shadow advertised for the position a decade after they purchased their first press. For Frank Janzen, the job at Crow's Shadow was "the opportunity of a lifetime." "It's every printmaker's dream to be able to set up a pressroom and work with quality artists from so many places," says Janzen. "It's so exciting to get up and come to work every day. It's never boring—there's always something different." Janzen's training at Tamarind prepared him well for the challenges of collaboration and running a print shop in which he can initiate new ideas. As an artist himself, he welcomes the chance to work in a creative environment—making his own images or collaborating with resident artists (fig. 7). He wants to introduce as many people as possible to the creative advantages of the printmaking process and is prepared to do so one person at a time.

The *Migrations* project presented Frank with three new individuals to indoctrinate into lithography. His collaborations with Steven Deo, Ryan Lee Smith, and Larry McNeil were immensely rewarding both for him and the artists. "It became clear that a crucial part of [Janzen's] role was to be sensitive to my visual aesthetic," observed McNeil. "Frank was very, very good at explaining and demonstrating the lithography process, especially the nuances of the inks as they interacted with each other and the paper." With typical humility, Janzen

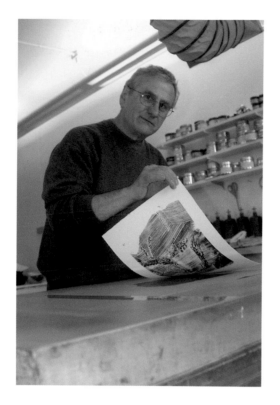

adds, "I learn as much from them as they do from me. It is indeed a dialogue." Deo called his collaboration a "wonderful, enlightening experience."

It was Lavadour's commitment and skill that sustained Crow's Shadow for many years. His contacts and personal achievements helped to interest non-Native people in the activities of Crow's Shadow. While this was an important aspect of his leadership, Lavadour felt that the organization's social and economic success depended upon the involvement of the Native community. Maintaining a delicate balance, he moved back and forth between his own work and the responsibility of running Crow's Shadow. He was concerned about the diversion, but also worried that Crow's Shadow would not survive without the level of passion and commitment he brought to the organization. Lavadour resigned as president in 2000 to devote more time to his own work. Now an advisor, he continues to contribute to fundraising efforts. Lavadour's recent donation of eight editions, sold at a very reasonable price, generated tremendous excitement and interest in Crow's Shadow, as well as considerable cash to help sustain the programs.

The current board of directors, made up of Native and non-Native people from

7. Frank Janzen prints an impression at Crow's Shadow Press.

the local community, has taken ownership and adeptly maintained the organization. Crow's Shadow has become a model for burgeoning Native groups that also want to establish independent art services within their communities. The Umatilla tribal government has asked Crow's Shadow to be involved in the development of arts-based programs for the tribe's new community school, Nixyaawii, which was inaugurated in the fall of 2004. The Nixyaawii students give Crow's Shadow the opportunity to involve more reservation youth in studio programs and to encourage them to pursue careers in the arts.

Lavadour's inspiration had its roots in his work with the tribal administration; he realized that artists needed to be taken seriously, they needed opportunities to show their work, and they needed institutions to support the creation of their work. He believed in the power of art in the context of social responsibility—and he created a place for art and community to come together rather than an environment where an attitude of "art for art's sake" permeated. The social principles of the Indian community were conducive to creating a place for artists, a place where culture and identity are inextricably linked. *Migrations* artist Larry McNeil

immediately felt the sense of generosity and creativity when he went to work at Crow's Shadow, and for that, he says, "Gunalchéesh, thank you." Crow's Shadow integrates traditional principles with modern needs and moves toward the future with a spirit of hope and ambition.

And for that, in every language, we say, "thank you." ❧

*As I've suggested, Tamarind is an institution that stands apart from some of the concerns typical of other art world institutions . . . in particular . . . the focus on the current season enforced by the market place.*

—Carter Ratcliff, 1985,
*Tamarind: 25 Years*

# A Quiet Commitment: Tamarind and Native American Artists

*Kathleen Stewart Howe*

In 1970 Tamarind Lithography Workshop left Los Angeles to become Tamarind Institute, a division of the College of Fine Arts at the University of New Mexico in Albuquerque. Tamarind's move to New Mexico brought about a slight change in its name but no change in its core commitments to fostering fine art lithography through artist-printer collaborations and the training a cadre of printer artisans.[1] As a division of an academic institution, Tamarind's commitment to pedagogy became more formalized with the development of certificate programs in printmaking culminating in the Master Printer program. Tamarind Institute also found itself part of an artistic milieu different than that in southern California. New Mexico was home to a large and diverse artistic community dispersed in centers around Santa Fe, Taos, Roswell, and Albuquerque, with Native communities on pueblos and reservations and Hispanic communities throughout the state. Director Clinton Adams envisioned a printmaking workshop that would welcome the multiplicity of artistic strategies and styles that New Mexico's burgeoning art scene encompassed.

Fifteen years later, in an exhibition celebrating twenty-five years of printmaking, prints by Native American artists Jaune Quick-to-See Smith, James Havard, and Fritz Scholder hung with work by artists more closely associated with the West Coast scene—Ed Ruscha, Sam Francis, Ed Moses, and David Hockney—and those from Mexico—Rufino Tamayo and José Cuevas. They were part of the spectrum of artists invited to Tamarind Lithography Workshop under Director June Wayne, or Tamarind Institute under Clinton Adams. Wayne and Adams had many ambitions for Tamarind—as a training program for a cadre of master printer artisans who would fan out across the United States and indeed the world; as a

8. Fritz Scholder
   *Indian with Feather (Indians Forever Suite)*, 1970.
   Lithograph, 30 x 22 in.
   Printed at Tamarind Institute by Tracy White.
   (Photo: Margot Geist)
   Courtesy of Tamarind Institute

professional print atelier at the service of artists; and as the premier lithographic workshop in the first decades of the rebirth of fine art lithography in the United States, a portal onto the rich artistic possibilities of lithography. Adams also knew that in New Mexico Tamarind Institute would have to earn its keep through publishing ventures and contractual work with artists. In 1970 when Adams developed plans for Tamarind's first publishing venture, he thought of Fritz Scholder (fig. 8), who was then teaching at the Institute of American Indian Arts in Santa Fe.[2]

Fritz Scholder later recalled that he had flirted briefly with lithography as a student at Sacramento State College but was disappointed with the results. "It was disastrous . . . very laborious and terribly technical."[3] But Scholder realized that this first exposure to the medium was unsatisfactory because he lacked the technical resources to really explore the possibilities inherent in stone lithography and the disappointing prints had not soured him on the process. When Adams approached him, he was interested in the idea of making prints with a collaborating printer in a professional print shop. In an intense period between December 1970 and the end of March 1971, Scholder undertook twenty-one

lithographs. Eight were issued as the suite "Indians Forever."[4] That first burst of prolific activity continued throughout the 1970s and early 1980s as Scholder editioned 186 prints at Tamarind. Other Native American artists from New Mexico followed—T. C. Cannon, Patrick Swazo Hinds, Dan Namingha, and R. C. Gorman. This flurry of creative activity attracted the interest of other Native artists; Jaune Quick-to-See Smith first came to work at Tamarind in 1979, the beginning of a long and fruitful collaboration that continues to this day (fig. 9). James Havard printed there in 1983. None of these collaborations were developed as projects specifically to attract and work with Native American artists. They were initiatives to work with interesting regional artists who would challenge the printers. As Adams described Tamarind's goal, "As a matter of principle—and as a practical necessity in the training of printers—Tamarind had always sought work that encompassed a wide range of technical and stylistic directions."[5] Tamarind was uniquely situated to respond to the full spectrum of interests of an extraordinarily fertile moment in contemporary art. By the mid-1980s, Tamarind Institute had acquired a reputation as a place where Native artists worked. In 1985 Clinton Adams retired as director

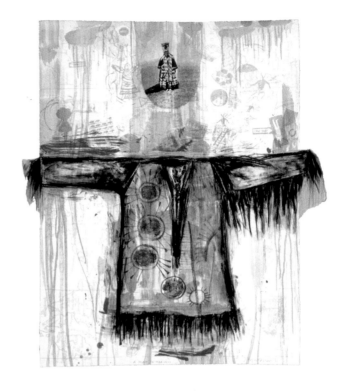

9.   Jaune Quick-to-See Smith
     *Map to Heaven*, 2002.
     Lithograph, 39 x 34¼ in.
     Printed at Tamarind Institute
     by Ulrich Kuehle.

of Tamarind Institute and was succeeded by Marjorie Devon.

In the late 1980s, an energized Native community began to curate exhibitions that resisted the large omnibus exhibitions designed to reconcile contemporary Native American art to older, more traditional art forms. Jean Fisher and Jimmie Durham presented an exhibition of Native American contemporary art at Artists Space in New York in 1987. *We the People* was designed to "challenge Western expectations of what 'authentic' Indian art is."[6] As Devon and Tamarind continued to work with Native American artists, they had a front row seat for the struggle of Native American artists to define their work beyond its ties to traditional cultural production.

These issues came to dominate critical and academic discourse as the five-hundred-year anniversary of Columbus's arrival in the Americas approached. In 1992 First Nation artist and curator Gerald McMaster organized the exhibition *INDIGENA: Perspectives of Indigenous Peoples on Five Hundred Years*, a salutary corrective to the celebrations surrounding the Columbus Quincentenary.[7] That same year the University of New Mexico Department of Art and Art History sponsored a two-day symposium, Art and Definition

of Self: Our Land/Ourselves, with speakers from the United States and Canada invited to "focus on expectations of American Indian art and artists—by self, by the academic other, by museums and the market, and by law."[8] In conjunction with this event, Devon invited artists Duane Slick, Phil Minthorn, Linda Lomahaftewa, and Mario Martinez to make prints at Tamarind. Their prints were exhibited at the University Art Museum during the symposium and the artists were invited to participate in the symposium.

The UNM symposium, *INDIGENA*, and *Our Land/Ourselves: American Indian Contemporary Artists*, an exhibition curated by Jaune Quick-to-See Smith and organized by the University Art Gallery at Albany State University of New York, were part of a constellation of events, exhibitions, and publications, including a thematic edition of *Art Journal*, "Recent Native American Art," responding to the increased prominence and critical status of work by Native American artists.[9] And despite the denial by the coeditor of this issue of *Art Journal*, W. Jackson Rushing—"This is not *Art Journal*'s Quincentenary issue on Native American art"—it seems clear that 1992 provided a vantage point from which to address the pressures on contemporary Native

art, as it provided an equally compelling point for discussions of the changes wrought on the American continent.[10]

Despite the fact that the number of projects focusing on critical issues in Indian art—issues of identity formation, authenticity, commodification, and marginalization—declined in much of the mainstream art world in the years following 1992, Tamarind Institute continued its engagement with Native American artists. In 1997 First Nation artist Robert Houle printed at Tamarind. Emmi Whitehorse began printing with Tamarind in the mid-1990s and continues to edition prints there. And, of course, Jaune Quick-to-See Smith continued her decades-long involvement with Tamarind. I think it likely that Smith's long association with Tamarind kept issues of Native artistic recognition in the forefront of the program's consciousness. When Smith began to print with Tamarind, she was a young artist with a distinctive vocabulary and set of concerns. By 1992 she had assumed a leadership role as an activist and spokesperson for contemporary Native American art, a role that she continues to this day. Smith has founded two Native American artists' cooperatives, organized over twenty-five exhibitions of contemporary Native American art, and served on the

board of the College Art Association, the first Native artist to do so. Through her practice as an artist and curator, her interest in education through art, and her role in the developing critical discourse, Smith's association with Tamarind has been a continuing conversation on issues central to contemporary Native art. Tamarind under Devon's leadership has been an eager participant in that conversation.

The projects devised by Devon to engage Native American artists in the years after 1992 seem a specific response to Kay WalkingStick's statement in the *Art Journal* issue devoted to Native American art.

It seems to me the best reason for mounting a show focused on ethnicity is to introduce new and different artists and their work to a diverse audience as a way of helping those artists to become established in the contemporary art scene, and also to broaden the viewer's appreciation of what constitutes art. . . . Not to receive serious critical review is a kind of disempowerment.[11]

They aimed squarely at the elements defined by WalkingStick—and introduced Native American artists to new audiences and

exposing their work to critical review. In 1994 Devon proposed a project to the City of Albuquerque Public Art Program to bring artists representing each of the state's nineteen pueblos to Tamarind to collaborate in making monotypes. The artists would retain the prints they produced except for two that would enter the Albuquerque Public Art Collection for permanent display in government offices and public spaces. The proposal to the Albuquerque Office of Cultural Affairs specified two goals: "to provide native artists with an opportunity to explore a new artistic medium . . . in an internationally known professional workshop, and to provide long-term, high-visibility exposure for their works of art."[12] The artists, selected through an open competition process, represented a broad range of artistic practice—traditional pottery, silver work, and painting—as well as artists who had received academic training in painting, printmaking, and drawing. The opportunity to work with artists as they investigated a new medium was exhilarating for Tamarind printers as was the working situation, which brought artists from different tribal cultural groups together and set the stage for a more ambitious project.

Tamarind has long prided itself on its preeminent role in training an international cadre of master printers. A world map hangs outside the conference room in the Tamarind office. It is liberally sprinkled with colored pins, each indicating the origin of a Tamarind student or the site of a workshop, lecture, or exhibition. The same global projection is featured on the Tamarind Web site, where red, green, and blue markers wink up at the viewer. The blue pin (or light) centered on Johannesburg, South Africa, where a Tamarind master printer operates a fine art lithography press, marks the unlikely genesis of the next project featuring Native American artists. As a New Year's greeting, Mark Atwood sent a calendar with color reproductions of the work of San artists that intrigued Devon and the Tamarind staff. They admired the quality of the work of these indigenous artists of the Kalahari Desert of Botswana. And it struck them that the traditional stories referenced in the San work would interest the Native American artists they had worked with on the monotype project. The cross-cultural communication that Tamarind staff had witnessed in the pressroom among the nineteen Pueblo artists, as well as among artists and printers, perhaps might be expanded to include other groups.

In 1999 Tamarind invited four San artists from the Kalahari to come to New Mexico,

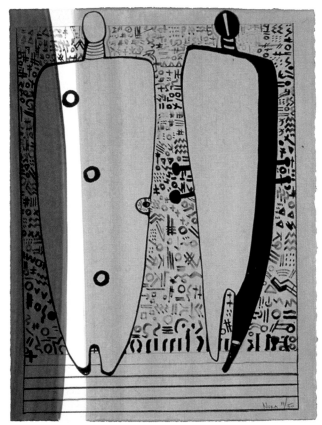

10. Thamae Setshogo works on a proof
    of his lithograph for the *Trickster* portfolio,
    with hand-colored lithographs
    by Coex'ae Qgam (Dada), Xgaiga Qhomatcã,
    and Cg'ose Ntcõx'o in the background.

11. Nora Naranjo-Morse's lithograph
    for the *Trickster* portfolio, *Culture Speak*, 1999.
    Hand-colored lithograph, 15 x 11 in.
    Printed at Tamarind Institute by Bill Lagattuta.

where they would share their experiences and stories with four Native American artists. African and Native American artists exchanged traditional stories in public sessions at Taos, San Felipe, and Pojoaque pueblos. Then the eight artists took up residence at Tamarind to work on a cycle of prints that reflected each culture's stories of the Trickster, a protean figure present in many cultures' narrative cycles. Each artist created two one-run prints, some of which were hand-colored (figs. 10, 11). The sixteen prints were editioned and presented as the "Trickster" suite.

The 1999 exhibition *Multiple Impressions: Native American Artists and the Print* explored the twenty-nine-year commitment of Tamarind Institute to Indian artists. Curated by Professor Joyce Szabo of the University of New Mexico Department of Art and Art History for the University Art Museum, the exhibition traveled to multiple venues in the United States and Latin America.[13] *Multiple Impressions* served as a summation of the ways in which Tamarind had encouraged Native artists to explore new processes and to edition prints for the art market. Curator Szabo, in the wall text accompanying the exhibition, stated: "From Scholder's initial work at Tamarind in 1970 to the summer 1999 two-

week oral and visual storytelling project that Tamarind conducted with visiting San artists from Botswana . . . and Pueblo artists . . . Native American artists have explored the rich potential of printmaking in collaboration with the Institute's master printers."[14]

Since 1970 Native American artists, through their work at Tamarind, have found increased visibility and access to art markets. Tamarind prints are exhibited at fine art print fairs, advertised in art magazines, and listed on the institute's Web site, all of which has brought the work of emerging or marginalized artists to new audiences. Through the Internet and the ubiquitous search engine as research tool, artists who previously may have been known only within a special interest area and on whom it was notoriously difficult to acquire basic information now have a presence in the expanding Web-based contemporary art market.[15] A query in Google directs the searcher to the Tamarind Web site where one can find biographies, exhibition histories, and examples of work. The desire, articulated by Kay WalkingStick in 1992, to see the work of Native American artists introduced to a wider and more diverse audience is met in part in the virtual gallery of the Internet, a sidebar of Tamarind's role as the publisher of fine art

prints. It is another step in Tamarind's history of presenting work by Native American artists and treating that work seriously.

Yet it is with the most recent project, *Migrations*, that Tamarind addresses the second element of WalkingStick's equation for equal access and opportunity for Native Americans producing art today—that of receiving serious critical consideration. The project *Migrations* was designed to bring emerging Native American artists, nominated by curators, fellow artists, and critics, to two professional fine art print ateliers—Tamarind and Crow's Shadow—to collaborate on prints for exhibition and publication (fig. 12). But the project did not stop at supporting emerging artists' exploration of printmaking processes. From its inception, *Migrations* was intended to redress the lack of critical appraisal cited by WalkingStick. *Migrations* introduced contemporary critics to the work of these artists by inviting the critics to visit the presses while the artists were in residence to foster knowledge of their work and to encourage the exchange of ideas. This volume presents the response of critics to their work. It should be noted that when Jean Fisher and Jimmie Durham presented *We the People*, they were ignored by the mainstream art media. In fact, Jean Fisher noted that the exhibition received only two reviews and one of those by someone whom she doubts saw the exhibition. The exhibition designed to "challenge Western expectations of what 'authentic' Indian art is" was met by resounding silence. *Migrations* is an answer to that silence. It answers WalkingStick's call for serious critical attention to redress the critical silence she identified as "a kind of disempowerment."[16]

The consideration of Tamarind's consistent and persistent engagement with Native American artists brings us to the statement by Carter Ratcliff with which I opened this essay. "As I've suggested, Tamarind is an institution that stands apart from some of the concerns typical of other art world institutions . . . in particular . . . the focus on the current season enforced by the market place." Tamarind, since 1970, has chosen to work with Native American artists. Once this commitment began, it persisted despite the changing whims of the market for contemporary art, which has sometimes embraced Native artists working as contemporary art makers, not tribal representatives, and ignored them at other times. Adams knew that the first publishing venture for the newly defined Tamarind Institute should both announce the institute's new identity and signal its intention to play a

12. Printer Jim Teskey printing
Tom Jones's lithograph, *Commodity II*
in the Tamarind workshop.
(Photo: Meg Larned Croft)

role in the art market. Adams solicited Fritz Scholder's participation because he admired him as an artist whom he thought would find lithography compatible and with whom he felt the institute could make a couple of great prints.[17] Not incidentally, Adams had also assessed Scholder as a "bankable" artist. Scholder's extraordinarily rich collaboration with Tamarind—proved Adams right on all counts. But Native artists did not need to have the name recognition and potential sales of a Fritz Scholder.

The leadership at Tamarind—Adams, and then Devon—sought connections with Native artists in the region, invited Native artists from beyond the Southwest, and devised and sought funding for projects that encouraged the use of printmaking by artists who use more traditional media. Perhaps Tamarind's position as a division within an academic institution provided a bit of insulation from the vagaries of market pressure. (Although it should be noted that a significant portion of Tamarind's operating budget is supported by sales of the prints they publish.) And perhaps some of it was the rather contrarian streak in Adams that became part of the institutional culture, albeit in a less brusque form, which decreed that Tamarind would not respond to the vagaries of a gallery driven art market but

maintain a consistent hold on the goals that informed its founding. I think that Adams's early recognition that the artistic expression of Native American artists was an important element of the art of our time and of Tamarind's place was critical to this history.

Over time, Tamarind's support for Native American participation persisted as the ways in which it was realized shifted. Perhaps the major change has been that under Devon's leadership, Tamarind Institute has sought institutional and governmental support to realize projects with Native American artists, while continuing the earlier model of inviting individual artists who might bring to the workshop interesting and challenging collaborations, whether they were Native or non-Native. There are now a number of print shops, many of them staffed by Tamarind-trained printers, who regularly and routinely work with Native American artists, and, of course, Crow's Shadow Press at Crow's Shadow Institute of the Arts has devoted itself to publishing the work of Native artists and fostering cross-cultural projects with a number of artists. Tamarind Institute has been a quiet leader in those developments. ✑

## Notes

1. The history of Tamarind Lithography Workshop and Tamarind Institute may be found in several publications. See, for example, Clinton Adams, "An Informed Energy: Lithography and Tamarind," *Grapheion: European Review of Modern Prints, Book and Paper Art* (first issue 1997): 21–28; Clinton Adams, *Printmaking in New Mexico: 1880–1990* (Albuquerque: University of New Mexico Press, 1991); and Marjorie Devon, ed., *Tamarind: Forty Years* (Albuquerque: University of New Mexico Press, 2000).

2. Adams, *Printmaking in New Mexico*, 80.

3. Clinton Adams quotes the statement: "It was disastrous. I took a class where we worked in lithography: I did the actual work, or was shown how to do it. Three prints were pulled in editions, a grand total of perhaps five impressions. The first was of a nude woman standing in a landscape, then a face of an owl, and a cat—but I didn't like the medium. It was very laborious and terribly technical" (Clinton Adams, *Fritz Scholder: Lithographs* [Boston: New York Graphic Society, 1975], 20).

4. In *Fritz Scholder: Lithographs*, Adams describes Scholder's intense engagement with lithography that resulted in the initial 1970/1971 series and his continuing exploration of the medium

over the next five years. The tally from the first collaborative effort was impressive: eight prints were included in the suite "Indians Forever," another print was editioned as *Abiquiu Afternoon*, three prints were abandoned, and the remaining nine exist in trial proofs or lettered impressions but were never printed as editions because of a dispute between the artist and his publishers (Adams, *Fritz Scholder Lithographs*, 29).

5.　Adams, *Printmaking in New Mexico*, 89.

6.　Jean Fisher, "In Search of the 'Inauthentic': Disturbing Signs in Contemporary Native American Art," *Art Journal* 51, no. 3 (Fall 1992): 44.

7.　*INDIGENA: Perspectives of Indigenous Peoples on Five Hundred Years* was organized by Gerald McMaster and Lee-Ann Martin at the Canadian Museum of Civilization as a response "to the Quincentennial hoopla."

8.　Excerpted from the conference brochure, a copy of which may be found in the archives of Tamarind Institute.

9.　This thematic issue, "Recent Native American Art" (*Art Journal* 51, no. 3 [Fall 1992]), published by College Art Association, was edited by Kay WalkingStick and W. Jackson Rushing. There were a number of significant exhibitions clustered around this period: *Shared Visions: Native American Painters and Sculptors in the Twentieth Century*, Heard Museum, Phoenix, Arizona, 1991; *Magic Images: Contemporary Native American Art*, Norman, Oklahoma, 1991; *The Submuloc Show/Columbus Wohs ( . . . Who's Columbus)*, organized by Jaune Quick-to-See Smith, 1992.

10.　It was also in 1992 that Walla Walla artist James Lavadour and a group of supporters founded Crow's Shadow Institute of the Arts on the Umatilla Indian Reservation. See Gerald McMaster, "Crow's Shadow: Art and Community," in this volume.

11.　Kay WalkingStick, "Native American Art in the Postmodern Era," *Art Journal* 51, no. 3 (Fall 1992): 15.

12.　I am grateful to Marjorie Devon for allowing me to review the files related to Tamarind's projects with Native American artists and to quote from this grant proposal.

13.　University of New Mexico Art Museum, Albuquerque, New Mexico; exhibition toured under the auspices of TREX, Museum of New Mexico, Santa Fe.

14.　Joyce Szabo, introductory text panel, *Multiple Impressions*, University of New Mexico Art Museum, 1999. I'd like to thank UNMAM Collections Manager Bonnie Verardo for providing me with copies of the exhibition text.

15.　It should be noted that the Bainbridge Bunting Memorial Slide Library at the University of New Mexico, under Director Sheila Hannah, has been a pioneer in organizing an online database devoted to Native American artists.

16.　Fisher, "In Search of the 'Inauthentic,'" 44.

17.　It should be noted that in 1975, then director of Tamarind, Clinton Adams, described himself as "honored" to write the critical essay accompanying the publication of *Fritz Scholder: Lithographs*, cited earlier.

# Multiple Migrations: (E)merging Imagery

*Jo Ortel*

In a review of the 2004 *Whitney Biennial* published in *Art in America*, critic Eleanor Heartney observed that the decade of socially and politically engaged art was over. Using the infamous 1993 *Whitney Biennial* as a foil, she argued—rightly, I think—that the art selected for inclusion in the 2004 show largely retreated from the "single-minded obsession with the world's ills." She felt that for the most part, the exhibit "scrupulously sidestepped direct social or political commentary for a focus on fantasy, nostalgia and escape."[1]

Like any survey, the *Whitney Biennial* tries to be expansive, yet always ends up being selective and exclusive. In their choices for 2004, the curators overstated the resurgence of escapism in contemporary art, in my opinion, and underrepresented art addressing issues of cultural identity. Although many artists have turned away in recent years from engagement with the world, identity politics and political and social concerns remain urgent, compelling subjects of investigation.

*Universal Experience: Art, Life, and the Tourist's Eye*, an exhibit curated by Francesco Bonami, Julie Rodrigues Widholm, and Tricia Van Eck that opened at the Museum of Contemporary Art in Chicago a year later worked as a perfect antidote to the Whitney show, because it offered a visually and conceptually rich mixture of socially engaged art.[2] The focus of the exhibit drew attention to the fact that, despite skyrocketing gasoline prices, we are still enticed by alluring destinations and exotic cultures. But the curators defined tourism and travel loosely enough to encompass a broad range of related topics, from nationalism and cultural appropriation, to the "social construction of places, spaces and identities" and border crossings.

No work by Native American artists was represented in *Universal Experience*, which was unfortunate because many Native artists address similar issues—from distinct and varied perspectives. In making art of an experimental nature, contemporary Native

American artists traverse many (internalized as well as externally imposed) borders. Like a good number of the artists in *Universal Experience*, the artists selected for Tamarind's *Migrations* project, for example, probe what it means to be part of a community—or an outsider looking in. And, like so many artists working in far-flung regions of the world, Native American artists are also attracted to those places where illusion intersects reality. They, too, explore how images and ideas migrate or shuttle back and forth between cultures, and many use the visual vocabulary of postmodernism to untangle these relationships and relocations.

It is this kind of oversight by influential curators and art institutions that Tamarind Institute has long rejected, as Kathleen Stewart Howe's overview in this volume makes clear.[3] Tamarind's commitment to collaboration with artists from all corners of the globe runs deep, but its flexibility is, in many ways, at odds with the entrenched nature of much of the art world, which, despite its very loud protestations and assertions to the contrary, continues to be entrenched and heavily invested in delineating and policing its borders. Heartney is not alone in detecting a "return to order" in artistic (and curatorial) practice. On many levels,

Tamarind's *Migrations* project keeps those borders fluid. It reaffirms the truth and necessity of James Clifford's assertion, made nearly twenty years ago: "Culture is migration as well as rooting—within and between groups, within and between individual persons."[4]

Certainly, for the six individuals selected for the Tamarind project, the migrations are multidirectional and multidimensional. They encompass psychological as well as physical journeys. They enfold art and life, individual and community. Most importantly, they involve a deepening of cultural understanding and self-knowledge.

Tom Jones is a prime example. His principal medium is photography, and his subject is the Wisconsin Ho-Chunk.[5] Using black-and-white and color, and working in a documentary style, his overriding interest is in honoring and recording the community. He photographs tribal elders, war veterans, pow-wow dancers, and children. His mother, a Ho-Chunk, was raised in the Indian Mission community outside Black River Falls, Wisconsin; Tom was born in North Carolina in 1964 and raised in Florida and Minnesota. In summers, he and his siblings were sent to their grandparents in Wisconsin. When he was fifteen, the family moved back to

Madison, Wisconsin, from whence Tom con-tinued to travel regularly by bus to visit his grandparents at the Indian Mission. He received his BFA from the University of Wisconsin–Madison in 1988 and did graduate work at Columbia College in Chicago, where he studied photography.[6] While there, he began making photographs of his beloved grandfather and other tribal elders. "When I started the project with the elders, I saw it as a way to record contemporary images of Ho-Chunks, and to learn from them."[7] He began the project feeling like an outsider because he grew up outside the community. Only gradually did he realize that, although he had a great deal to learn, his mother had instilled in him the most fundamental Ho-Chunk values.

Lucy Lippard once noted, "Portraits are difficult enough to make in the best of circumstances. Portraits of Indian people have a horrendous history and are consequently even more difficult." She went on to write, "Tom Jones solves this problem unselfconsciously, choosing to shoot in black and white so that he can refer back to the romanticism of historical Indian portraiture (taken of course primarily by white men), particularly that of Edward Curtis, a figure toward whom Native people are mightily ambivalent."[8] Jones's photographs give

a nod toward the troubled history of his chosen medium without conceding any ground. Whereas Curtis was on a mission to photograph a "vanishing race," Jones presents a resilient and flourishing community.

Among the strongest images are *Choka Watching Oprah* (1998) (fig. 22) and *Nina Cleveland* (1998) (fig. 23), which, in addition to being about community, provocatively engage contemporary photographic theories. Of *Nina Cleveland*, critic Robert Cozzolino has written,

> Nina sits before a big Sanyo television flanked by two large speakers. Photographs of children cover all available surfaces and rest on a shelf line just above Nina's head. Some look out at us, others look over her shoulder, and some appear to regard this fascinating matriarch. The children focus their eyes at the camera (twice in time), but Nina's eyes are hidden to us. Wearing sunglasses, she remains mysterious.[9]

Thus, the image interrogates the relationship between sight and insight, absence and presence, even as it presents a cherished elder in her familiar domestic environment.

At the same time, Jones's photographs often work against the grain of photographic theory. For one thing, they frequently engage the auditory: we can hear the singers' high-pitched notes, the drumbeats, even the whirring of the tape recorders in *Honoring the Ho-Chunk Warrior: Drummers* (2002); we can hear the drone of the television, the deep breathing of a dozing grandfather in *Choka Watching Oprah*. It is quite striking to find this in a medium that is so frequently associated with muteness. (Documentary photographs, after all, notoriously strip their subjects of agency and speak *for* them.)

In 2001 Jones moved away from straight photography to create a more politically charged series entitled "Dear America" (completed in 2002). For this suite, he selected images of Indians from vintage postcards and photographs, which he digitally manipulated and juxtaposed with handwritten text about little-known historical events and lines from the song *America*. He has written that the series developed from his need "to portray the Native American experience and the contributions to the history of the United States of Native peoples, who have been largely without voice in an American history education."[10]

In the swirl of heightened nationalism following 9/11, "Dear America" takes on added meaning. What does it mean—to different groups at different moments in time—to be proud and patriotic? In *My Country 'tis of Thee* (fig. 25), Native and non-Native women are incongruously clustered around a billowing flag. "These colors will not run" is superimposed along the lower margin. It is a phrase that appeared on one of Jones's 1940s-vintage postcards; it has, of course, resurfaced as an expression of twenty-first-century American resolve. The piece reminds the viewer of earlier invasions of these shores carried out by our forefathers. The series sets contemporary events in historical context and collapses the distance that separates myth from reality.

*Commodity II (Souvenirs for Tourists)* (fig. 28), one of the prints Jones made at Tamarind, investigates the objectification and commodification of Native America using digital facsimiles of vintage cards and other memorabilia from his collection. To each print in the edition, the artist affixed a pair of miniature, beaded moccasins and a beaded canoe that he made himself—objects conventionally considered souvenir items. Ironically, countries in Asia, seeing a lucrative market, now mass-produce many of these "authentic" Indian trinkets, a dimension to which Jones also alludes. The print asks us to

consider what, really, is being sold in objects and images such as these, and who profits? It is a popular subject among contemporary Native artists, as Lucy Lippard notes in this volume, one that is itself in danger of becoming a cliché. Still, insofar as all the images Jones used in *Commodity II* were readily available on e-Bay, there would seem to be a continued need for such cultural critique.

But I want to propose a second reading of this print. In attaching handmade objects usually destined for the tourist trade to each individual "fine art" print, the artist leads us to consider the classification of "artful" objects. Tourist art, fine art, high and low art: what distinguishes one from the other? As art historian Ruth B. Phillips has written, "'Touristic' summons up the inauthentic, the mass-produced, and the vulgar, while 'art,' in the Western tradition, is identified with the beautiful, the rare, and the elite."[11] The fine art print is a similar source of confusion.[12] Neither exactly a unique object nor mass-produced, it occupies an uneasy place for some people. When "tourist art" is conjoined with "fine art print," standard classifications become even more scrambled. On the editioned print, the handmade "trinkets" function as tangible signs of the hand of the artist. Consequently, every print in the edition becomes potentially

more desirable to art collectors who place a high value on the unique object. Jones thus increases the economic value of his prints even as he slips in a wry commentary on the very culture of collecting. Indeed, collectors themselves are implicated in the web the artist (who is also an avid collector) weaves between ownership and desire, cultural authenticity and artistic originality.

*Commodity I* (fig. 27), Jones's other *Migrations* print, tells a more pointed story of how government policies have adversely affected the health of Native Americans. As Native peoples were removed from their accustomed environments, entire ways of living were disrupted and diet was affected. Confinement on reservations worsened matters. In response, the government provided annuities and food rations. Yet frequently the processed food commodities were rotten and inedible. These changes in diet occurring over a relatively short period have contributed to the degradation of health among Native Americans.

In his print, Jones floats text beneath an exquisitely rendered can of "beef with juices" and sets both within the circle of a traditional medicine wheel—a symbol of hope and healing.[13] To strips of beaded rawhide at four evenly spaced points on the wheel, the artist

has attached facsimiles of government-issue ration cards, the type that were distributed to Indian families. As in *Commodity II (Souvenirs for Tourists)* (fig. 28), a bold design of traditional Woodland appliqué wends its way across the upper and lower margins of the print. The text explains that "Type 2 Diabetes is largely a consequence of the rapid destruction of the traditional diet of Native people, and the substitution of our traditional diet with the diet of poverty: government commodities, fast food, inexpensive foods purchased at the store," and it further reports on studies that offer hope for combating diabetes and improving Native health. Thus, Jones's print charts the history of declining health among Native Americans, and it offers solutions for the future.

Jones is not alone in drawing attention to health issues, and to diabetes in particular, a disease that afflicts proportionally more Native Americans than any other group.[14] In 2004 fellow *Migrations* artist Steven Deo made *Frybread Kills*, a striking 11 x 17 inch poster to serve as a public health announcement. James Luna has also created performance pieces around his own diabetes and the regimens that the disease inflicts on him. In one, for example, he ritualistically prepares a meal and tests his insulin levels.[15] Like his

fellow artists, Tom Jones sees his work as one way to raise consciousness about an issue critical to the survival and well-being of the community. Acceptance and recognition represent the first steps in healing.

Star Wallowing Bull, a largely self-taught artist, has a more intuitive conception of artmaking. Born in Minneapolis in 1973 to an Ojibwe father (artist Frank Big Bear) and Arapaho mother, he began making art at a young age: "When I was just a year old my father set me in his lap, put a pencil in my hand and started me drawing. He always told me about our family and friends who would come by to visit so they could watch the baby draw."[16] When his parents separated shortly thereafter, Star and his younger sister first lived with their mother from whom, he writes, "We did not receive the best of care. She did her best to love us, but it was not enough due to my mother's chronic alcoholism."[17] Two years later, his father gained custody and the children returned to the south side of Minneapolis where they grew up. With his father's encouragement, Star resumed drawing until adolescence, when alcohol and drugs consumed his life. At seventeen, he dropped out of high school; his addictions worsened. It was not until 2001 that he began the arduous path to recovery—significantly,

after having a prestigious fellowship from the National Museum of the American Indian in New York rescinded on account of his alcohol abuse. "I credit the NMAI with my sobriety," he told me. "If it weren't for them, I'm sure I wouldn't be here today."[18]

His art has played a central role in his recovery. Through treatment and beyond, his elaborate, detailed drawings executed with Prismacolor pencils have served as a means of ordering and making sense of his universe. Abstract patterns weave between exquisitely realistic figures and forms. Size and scale continually shift as one image flows into another. The drawings chronicle his journey back to emotional, spiritual, and physical health and his struggles along the way. "My art is my Higher Power," he says now. Of *Twinkle Twinkle Little Star Now I Know Who You Really Are* (fig. 48), for example, he writes,

> In the center of the drawing is a photograph of myself as a young boy, underneath written in Ojibwe it states, "I am reborn." I chose to collage the actual photograph, as opposed to drawing it, as I wanted to stress that it represents my real self—as opposed to being lost, in denial . . . Using the photograph

seemed a better way to express this, as this drawing is about healing difficult situations that began in my childhood. So the drawing deals with my present experience as an adult but specifically with my inner self, the lost child inside me that I am getting to know as time goes on.[19]

Wallowing Bull creates interlocking vignettes often using recognizable icons, characters, and motifs from American pop and global cultures. These he sets cheek by jowl with Native American and Ojibwe signs and symbols and text written in Ojibwe.[20] As Todd Bockley has noted, he "uses cultural icons like Our Lady of Guadalupe that are broadly recognizable, to enrich the narrative of the drawing, to reinforce the theme of the drawing."[21] But the icons also carry layers of personal meaning. When I ask about a menacing ape, the artist explains that it represents the old adage, "a monkey on my back"—which, in his case, felt like a full-grown gorilla. Of Pinocchio, he says, "As sick as I was, I didn't feel real. I felt like I was made of wood. I lied a lot when I was drinking." He draws my attention to the beer bottles strewn on the ground beside Pinocchio in the left portion of *Mind to Mind Combat* (2001)

(fig. 46). Months later, Pinocchio reappears in the right half of the work as a healthy, flesh-and-blood little boy.

Today, Star finds these drawings "overwhelming and suffocating." Gradually, they have given way to a more unified visual world. And it is clear that the opportunity afforded by Tamarind to explore new materials and to collaborate with master printers marked a critical juncture. His print entitled *A Moment of Silence* (fig. 52), for example, is a simple, stylized portrait of a circus clown in a ruffled suit holding a flower in his right hand. Along the top margin, a vine of flowers meanders against a black background. With his hat tipped at a jaunty angle, he might be a distant cousin of Picasso's harlequins or Fernand Léger's tubular women. Yet if the details suggest merriment, the clown's expression is somewhat puzzling. His lips are parted in a menacing grimace.

The print, the artist tells me, is a self-portrait. He had recently moved from Minneapolis to Turtle Mountain Reservation in northern North Dakota with his girlfriend, and he had grown increasingly unhappy. Isolated and removed from familiar surroundings, he found it difficult to adapt to reservation life. The print describes his state of mind at the time. The title refers to his emotional withdrawal from his girlfriend, while the flower he holds in his hand, a thing of beauty, represents his dream for happier circumstances.

I was surprised by Star's explanation because the staff at Tamarind had told me the artist had assured *them* the clown was happy. But it strikes me that his deception in fact heightens the truthfulness of the image. Like the clown whose painted smiling face masks an inner sadness, Star's positive "spin" concealed his true feelings about what the image represents. Things are never what they seem. Appearances can be deceiving.

*A Moment of Silence* lends itself to a second, related interpretation. It can, I think, be read as a metaphor for the transformational power of art in this artist's life. At first glance, the image seems simple and straightforward, but it is actually quite complex, consisting of at least four different systems of representation, or four distinct degrees of abstraction. The clown represents one level of stylization. The decorative border, which is loosely based on Ojibwe ribbon work design, represents the second; it bears none of the shading or modeling that defines the clown's suit. The clown's hand represents a third, more linear way to represent three-dimensional form on a two-dimensional surface. Finally, the shapes encircling the clown's head represent a fourth

level of abstract representation, for they only gradually coalesce into schematic renderings of acrobatic circus performers; seeing these highly abstract forms as shape-shifting trapeze artists or somersaulting gymnasts takes effort. By blending several distinct levels of abstraction and representation (or "realism") in a single image, the print suggests that its creator has the ability and the flexibility to imagine other realities—and re-create his own reality.[22] With a flower taking the place of his Prismacolor pencil (and the lithographic crayon), *A Moment of Silence* might be read as an emblem of the magical role art plays in this artist's life.

In Wallowing Bull's second print, *My Three Sisters* (fig. 51), we see three women set against a landscape. In the background at left, a man in a top hat holds an open umbrella. At right, the skyline of Minneapolis is visible. The girls represent the artist's sisters, the man his father—and when the print is compared to family photographs, the resemblances are striking despite the artist's stylized rendering. Animals give the image an added storybook quality. At the lower right, a coyote and a hare scamper through the land, while an armadillo (per the artist) ambles at left, and a fish-shaped blimp and a thunderbird hover above. The rabbit is an important animal

in Ojibwe culture, but here, it additionally serves to draw our attention outside the image. In this small detail, the artist gives an almost imperceptible nod to his printer-collaborator, Deborah Chaney, whose chop, a scampering rabbit, is embossed just beyond the lower right corner of the print.

Star's art has continued to evolve since his residency at Tamarind. Though perhaps not representative, *The Curious Crawler* (2004) (fig. 50), a drawing made with Prismacolor pencils and a #5 lithograph crayon (the same kind he used at Tamarind), is indicative of one new direction.[23] It vividly conveys the neglect the artist imagines he and his sister endured as very small children. Amidst strewn toys are crushed beer cans. Flies circle the baby's unchanged diaper. A pan burns on the stove. Handprints made with spaghetti sauce mark the wall. Partly concealed behind a partition, his mother lies passed out on the kitchen floor. As heartrending as the scene is, it is also endowed with a great generosity of spirit. With its cartoonlike exaggerations, the drawing is just buoyant enough to keep us from turning away in despair.

Steven Deo refuses to be constrained to one single aesthetic. He made two stylistically divergent prints for *Migrations*. *Alluvium* (fig. 19) utilizes a boomerang-shaped form

that appears often in his large, abstract paintings. The other, entitled *Principle of Identity* (fig. 20), features photo-images overlaid with text.

Personal memories and family stories are commemorated in works such as *Passages through Modernity* (2004), *Perpetual Stream* (fig. 14), and *The Source of Solar Energy*. In the first, a portrait of Bob Wills, a country-and-western singer from Texas, is superimposed over an old photograph of the artist's father as a young Naval officer flanked by his proud and smiling mother and his uncle George. In the upper right, a pocket watch symbolizes modernity and the passage of time. "When I made this piece, I had just recently learned that my grandparents had lived in Tulsa. So you might say I'm a third-generation urban Indian," Deo explains, with a twinkle in his eye.

> That is, my grandparents moved to the city for work during the early fifties, after raising my father in the country. They spent more time in the city than I realized. I never knew it, but my grandfather had been a taxi-driver. After hours, he worked as a janitor at a famous country-and-western gathering place where

he got to know Wills and became his occasional chauffeur. When the singer died, my elderly grandfather attended the funeral, and was even invited to sit with the band members and the family.[24]

Within his recent family history, Deo has many examples of how different individuals have responded to momentous cultural change and modernity. Born in Oklahoma in 1956, the eldest of five boys, he was raised in a blue-collar neighborhood on the west side of Tulsa. His parents, both full-blood members of the Euchee and Creek nations, "made the conscious decision to acculturate their sons into the public school system and mainstream culture."[25] But time spent with his grandparents and other family members was also cherished. For example, Steven remembers George, the same man who appears in *Passages through Modernity*, as a much older man who spoke little English and returned to rural life and more traditional ways. *Perpetual Stream* commemorates one memorable visit when his father asked George to take Steven and his brothers fishing "in the old Indian way." Deo remembers gathering a particular marshland plant, pounding its roots, and setting burlap bags filled with

them in a wide circle in a stream where the plants' secretions caused the fish and other wildlife to jump out of the water onto the stream's banks.

As Deo recounts the story it is clear that the excursion, which occurred when he was about eleven, remains vivid even today. At some level, it must have been a revelation of the kind of knowledge that was being extinguished through dislocation, relocation, and acculturation. But as we talk about *Perpetual Stream*, the artist introduces another idea: just as the fishing expedition inevitably impacted Steven and his brothers differently, shared identities are never experienced or understood in the same way by every member of the group. Each individual will have a unique perspective on what it means to be, say, a Creek, a Euchee, or an American. Thus, the puzzle pieces Deo used to form the figures are a symbol of the formation and transformation of cultural identity and the reclamation and reconstitution of knowledge by successive generations.

In *The Source of Solar Energy*, Deo explores the idea of parallel systems of knowledge more fully and directly. His maternal grandfather was a hereditary Euchee chief and a founder of the tribe's Duck Creek dance grounds in Oklahoma: "As a child, as far back as I can remember, I danced at Duck Creek during our green corn ceremony." Steven was also raised in the Christian tradition. When he moved out of his mother's house as a young adult, he began his serious engagement with the religious traditions of his grandparents and learned the medicine ceremony as taught by both of his grandfathers; he returns to Oklahoma annually to participate in tribal celebrations and ceremonies. In *The Source of Solar Energy*, a periodic table and scientific formulas are superimposed on images of Euchee ceremonial dances. In their own language, the Euchees' name for themselves is *tsoyaha*. As tsoyaha, or "Children of the Sun," they perform an annual ceremony that ensures the sun's rising; for them, the ceremony is the source of solar energy. Thus, two frameworks for understanding and organizing the world coexist in the space of a single composition.

Steven Deo tries to fit the many pieces of his multicultural heritage together. He is accepting of the ways individuals, like his parents, have adapted to disorienting cultural change in order to survive. Nevertheless, his art offers a pointed critique of the devastation that the violent and abusive suppression of Native cultural traditions and reeducation and assimilation policies have

inflicted on generations of Native people. In *Indoctrination No. 3, When We Become Our Role Models* (fig. 15) and *Child's Play* (fig. 17), for example, he explores how cultural values are instilled and assimilation and conformity enforced. The prohibition against speaking Native American languages put into effect in government-run boarding schools in the late nineteenth century; the normative example of fair-skinned Dick and Jane in primers up through the 1960s; the culture of violence we instill in our children through the toys we give them—Deo shines a light quite literally on how we learn who we are.

In *Principle of Identity*, one of the prints he made for *Migrations*, Deo deftly blends his personal history and identity with his more studied investigation of identity formation. Here, a train engine collides with an old photograph taken at the Carlisle Indian School, a microscope, and text explaining forms of "logical" reasoning. Images that reference the industrial landscape of his childhood serve as a broader critique of cultural homogenization and the steadfast American belief in progress.

Like his large abstract paintings, *Alluvium* evokes aquatic life. The arclike forms resemble schools of shimmering fish, though they can also be read as fossilized skeletons,

remnants of past life. Deo likes this ambiguity—the way an abstract shape can simultaneously suggest water and earth, life and death, movement and stillness. The title only serves to tighten the knot: *alluvium* refers to silt, sand, or similar detrital material that is deposited by moving water. Thus, through visual and verbal punning, he draws seemingly opposing terms into more intimate association and reveals their critical interrelationship.

"It always goes back to story," Larry McNeil tells me. "The prints are really about story."[26] Brief or extended, told in words or images, stories take myriad forms. A story may unfold visually, in a single mark, or in the space where word and image intersect. A story may assume legendary proportions or have fleeting significance; it may be tragic or comic, prophetic or historic. McNeil's prints embrace this multiplicity. Like a *Far Side* sketch, they contain elements of that most abbreviated story, the single-frame cartoon. But they also draw into their orbit a far wider constellation of narrative forms and structures, texts and subtexts. With images appropriated from *Lone Ranger* adventure comic books and bathroom stalls, with dialogue that pokes fun at Edward Curtis, Hollywood films, and postcolonial discourse, McNeil's prints really are about story.

"I've always considered that Curtis was trying to make genocide into something poetic in his series of photographs of Indians," McNeil says. The photographs to which he refers are the iconic images of American Indians made in the early twentieth century by Edward S. Curtis. They have become fixtures in American visual culture, perennially republished as lavish coffee table books. Convinced that the American Indian was doomed to extinction, Curtis embarked on a project to photograph and catalog all the known tribes.[27] But his images were highly subjective. As Katherine Hauser has written, "By emphatically not representing either his own contemporary present or that of his subjects, and paradoxically using a modern medium to construct a romantic past, Curtis created distorted images that established the myth that the Indian 'vanished' at the turn-of-the-century."[28]

From McNeil's perspective (and he is not alone), the myth worked as a convenient justification for the mistreatment, removal, and genocide of indigenous peoples of the North American continent. "How am I to make sense of that?" he asks. "And how do I reconcile the story Curtis's photographs tell with my own existence in the twenty-first century?"

One way is to reassemble it, tell it from a different vantage point. As Pulitzer Prize–winner N. Scott Momaday has written, "We are what we imagine. Our very existence consists in our imagination of ourselves . . . The greatest tragedy that can befall us is to go unimagined."[29] In his *Migrations* prints, Larry McNeil humorously imagines Curtis's project from his subjects' perspective. In the famed photographs, American Indians are stoic, heroic—and mute, forever suspended in a hazy sepia-toned past. In McNeil's prints, they are feisty and contentious. And they *talk*. What's more, they talk in the fumbling English of Hollywood movies *only when they remember to*. Most amusingly, they use the buzzwords of postmodern, postcolonial discourse to poke fun at all of Western "eepissedamollygee." This is an artist, in short, who reassembles the shards of language and the fragments of old stories to envision new ones.[30]

"We are all made of stories," the artist notes. But in his Tlingit culture, stories bound up with group (or family) identity expressed through visual art are especially important, and McNeil's ties to his cultural heritage are strong.[31] Even as he is also part of mainstream culture, he feels his Tlingit identity drives everything he does, always.[32] The third youngest

in a family of eight children, the artist (born 1955) grew up in Juneau and Anchorage, Alaska. His father, a commercial fisherman, is Nisga'a; his mother was "among the first Tlingit students to be allowed into the public school system in Alaska," and she went on to earn valedictorian status in spite of constant racial harassment and bigotry.[33] In 1975 Larry McNeil moved to Santa Barbara to study photography at the Brooks Institute. Upon receiving his MFA from the University of New Mexico in 1999, he joined the faculty at Boise State University where he continues to teach as an associate professor of photography.

Everything associated with tradition in Tlingit culture is linked with story, according to McNeil. In turn, the stories routinely wrap around both the verbal and the visual, just as his own art encompasses both word and image. In their book, *Native North American Art*, Janet Berlo and Ruth Phillips report that throughout the Northwest Coast region, "visual art and performance are integral to the narration of family histories. Inherited images, known as crests, symbolize these histories."[34] But David Penney stresses that "crests must be understood in the context of how they are presented and seen. Each generation must claim the stories and names from the past, by family right, but also by

public acknowledgment."[35] This is done at a potlatch ceremony at which "others are invited to witness the claiming of names, the telling of stories, and the display of objects with images of animals and spirit beings recalled from the ancestral past."[36] Chilkat blankets similarly have stories associated with them, according to McNeil, and these are passed on from generation to generation along with the handwoven robes. McNeil's cultural heritage, then, explains the centrality of storytelling to his artistic practice and the accretion of story in his artwork.

Compositionally and formally, *Edward Curtis' Last Photograph* (fig. 35) and *Native Epistemology* (fig. 36) are simpler and less complexly layered than much of McNeil's recent work in digital and new media. The medium imposed certain constraints and he was restricted by project parameters to five colors. Still, with every layer, he introduced subtle markers of personal narrative. Among the printer's inks, for example, he found the precise shade of what the Northern Tlingit call Chilkat blue, which resembles a shade of turquoise that was achieved via a copper patina process. The color also appears in traditional Chilkat blankets when they are newly made. The dorsal fin of a killer whale (framed by the lacy edges of Kodak film) references

his clan. A faint, subtly rendered camera lens diagram functions as an homage to photography and to his own twenty-year career using a Hasselblad camera before he switched to digital. Even the crude markings etched into the background carry meaning. As a direct transcription of graffiti the artist found in a restroom on a trip with his son retracing his own earlier migration from Alaska to southern California, these rough incisions bring us full circle. "The work could just as well be images chipped on cave walls, sculpture, painting, video, or finger paint," he wrote of earlier works in his "fly by night mythology" series, to which his *Migrations* prints also belong.[37] Storytelling can take any form. McNeil moves with agility between high art and popular culture, old and new, historical and contemporary; he enjoys the paradox of finding the former in the latter.[38] He takes clear delight and believes fully in the assertion that "the traditional and the contemporary are both traditional and contemporary."

Ryan Lee Smith works in a very different aesthetic. His prints and paintings are resolutely abstract, though his lines and forms seem always about to collapse into recognizable shapes or fantastic spaces. They are suggestive, yet in the final analysis, they refuse to yield their meaning.

Smith draws freely from a multitude of visual legacies. As he states, "My art is honest and influenced by many things. I love catfishing, eating tomatoes, and watching it rain."[39] In any single work, he may mix elegant calligraphic marks with bulbous, exaggerated, cartoon-inspired shapes and forms. He might execute an oil painting, like *Mouth Full*, that tips toward abstract expressionism and then reverse course and create a painting, like the long, narrow *Welcome Sign*, that has the swift flourish and verve of urban graffiti. As he does in *Velveteen*, he might move in a single work from tentative abstraction to fantastic realism. Sometimes the compositions seem inspired by architectural plans, ornamental baroque filigrees, or aerial views of urban spaces; other times, the line resembles that of Arshile Gorky, the figure-ground relationship recalls early Willem de Kooning paintings. Here, lines interlock like half-completed jigsaw puzzles; there, the composition seems to coalesce into menacing comic-book scenes of destruction. Smith has absorbed the full range of contemporary visual culture, and moves easily within it. Like many artists working today, he dispenses with an array of ideological boundaries—ethnic, artistic, racial—and refuses to be "penned" in.

At the same time, he is intrigued by his

own compulsion to make marks. "Trying to understand this drive to make marks on things for other people to look at is what amazes me and keeps me working," he states. One imagines his fascination encompasses all such human impulses. Certainly it is the process—the act of mark-making—that dominates his work. "When I paint, nothing is preconceived," he writes. "Subject matter is not important to me . . . I like to work spontaneously, combining everyday observations with past experiences and whatever my thoughts or concerns are at that time . . . The best way to put together a sandwich can be my main concern while I am working. Anything can influence where a line might decide to stand or how close a color wants to lay next to him."

Born in 1972 in the heart of the present-day Cherokee Nation, Smith grew up in rural Oklahoma, outside Bristow, a town of twenty-two hundred people. At school, the focus was on sports, so Ryan wrestled and played football for most of his school years. He writes, "The things that were important to me as a teenager were cars and art. Things haven't changed much since."[40] As an undergraduate at Baylor University, he studied painting. After some years living in Colorado, he entered graduate school at the University of New Orleans where he is currently working on his MFA.

When pressed, Ryan Lee Smith articulates the connection he makes between his work and his Native heritage:

Upon approaching a blank canvas, I create a composition that meets the expectations of the viewer, "a formally ideal composition." This ideal composition represents the ideal environment that our ancestors created. [Then] I use white to paint out or maybe paint in the idealistic expectations of a good painting. Much like the smallpox epidemic and measles-infested bedding our people were given out of a false generosity, my paintings represent the removal of the ideal and manipulating it to appear collectively beneficial and successful, mirroring the so-called justification of the relocation and control of our people.

There is, I submit, another way to think about the connection between Smith's art and his Native identity. Modoc author Michael Dorris once wrote, "In a certain sense, for five hundred years Indian people have been

measured and have competed against a fantasy over which they have no control. They are compared with beings who never really *were*, yet the stereotype is taken for truth" (emphasis his). It has been the vogue, he concluded, "for Europeans to describe Native Americans not in terms of themselves, but only in terms of who they are (or are not) vis-à-vis non-Indians."[41] Native American artists are similarly circumscribed. The assumption is that, as a Native artist, one's work is polemical, message-driven, and saturated with historical references and cultural critique, or it panders to market impulses.

When one's identity is so thoroughly prescribed and overdetermined, it seems plausible that one might carve out a space in one's art simply *to be*. This, I suggest, is what Ryan Lee Smith is doing. By his own admission, subject matter is unimportant. His art is neither representational nor symbolic. It carries none of the familiar markers of Native American art. It represents nothing more—*nor less*—than itself. In 1966 Susan Sontag wrote, "the flight from interpretation seems particularly a feature of modern painting."[42] For a Native artist working in 2005, a similar resistance to interpretation is itself, paradoxically, an enormous political statement. In a very real

sense, it is a straightforward assertion of the fundamental right to exist within the present.

The delicacy of a moth's wing, the shadowy space between the clock and the bed that looms large during a bout of insomnia; small details fill Marie Watt with wonder and become the basis for thoughtful, elegant works of art. Through her art, she draws attention to the unnoticed parts of our lives. "I am particularly drawn to the human stories and rituals implicit in everyday objects," she has said. "Like blankets, bridges, and doorknobs. Made familiar by use and scaled to the body, they often go unnoticed but make me think about the relationship between part and whole; I wish to capture this sense of familiarity in the objects I make."

Officially a member of the Seneca tribe of upstate New York, where her mother was raised, Marie Watt (born 1967) grew up in Redmond, Washington. She credits her knowledge of and commitment to her heritage to her mother's change of careers.[43] Originally trained as a nurse, her mother became a specialist in Indian education—work that brought the family new friendships and connections to the urban Indian community of the Northwest.

As a student at Willamette College in Oregon, Marie Watt enrolled in an art class

(with no idea of becoming an artist) and found that it resonated with her. Art, she discovered, "gave her a way to explore [her heritage, her connection to the world, to other people]."[44] She went on to study at the Institute of American Indian Arts in Santa Fe and at Yale, where she received her MFA. She has been teaching art at Portland Community College in Oregon since 1996.

In 2002 Watt exhibited works in a solo show entitled *Sleep and Sleeplessness*. For one installation, *Blanket/Sieve* (fig. 54), she arranged white alabaster stones riddled with drilled holes on the gallery floor in a rectangle and paired these with a larger piece of alabaster carved into the shape of a bed pillow. One corner of the rectangle pulled toward the wall as if tugged by sleep. Yet the incongruity of soft bedding made out of hard stone alluded to the complexity of moving from wakefulness to slumber. A related series of minimalist drawings made with alabaster dust and white ink conveyed that same singular fraught sensation when the luxuriance of sleep is tinged with trepidation.

More recently, Watt has turned her attention to blankets. In these works, secondhand blankets and blankets bought at flea markets are both her subject and her medium. "My work," she writes, "is about social and cultural histories embedded in commonplace objects."[45] Though we seldom think about it, blankets enfold rich layers of history. A blanket may hold profound significance for a child, for example, or it may have been passed through a family from generation to generation. The associations are often, though not always, poignant. As the artist says, "We are received in blankets, and we leave in blankets." Her work "is inspired by the stories of those beginnings and endings, and the life in between."

Watt suggests that through our intimate and deeply personal relationships with them, blankets become extensions of the people who use them.

One of the great things about the blankets is that there is no such thing as a square blanket. People have inhabited them and worn them. You put the sides together and you think they are going to match, but they don't. They are really wonderful in that way. I love how each blanket has its own personality. As a result, they don't stack easily. They have this posture that is not really that different from

the human body. The blankets have a will of their own.[46]

They also have a vulnerability that is perhaps most evident in the satin bindings along their edges. Frayed and well worn, these soft remnants also captivate Marie Watt.

She speaks eloquently, too, of the special meaning and historical importance that blankets have for Native American cultures. Even today, they are given to honor individuals "for being witnesses to important life events—births and comings-of-age, graduations and marriages, namings, and honorings." "For this reason," she notes, "it is as much of a privilege to give a blanket away as it is to receive one."[47] In earlier times, they served as vital trade items between indigenous peoples and European settlers. In *Three Sisters: Six Pelts, Cousin Rose, Sky Woman, and Relations*, the towering stacks of folded blankets (held together with invisible cable) that rise to the sky from square cedar bases invoke the story of Sky Woman, who in the Iroquois (Seneca) creation story falls from an opening in the sky, which begins a chain of events that leads to the creation of life on earth.[48]

But *Three Sisters* and related pieces invite stories as much as or more than they convey particular stories and this, I think, is a critical

distinction between Watt's work and Larry McNeil's, for example. As artist and curator Truman Lowe has said, her work "involves and creates community."[49] To complete her imposing blanket tapestries, Watt enlisted the help of friends and family, and the sense of community that emerged is palpable in the finished pieces. More than seventy-five individuals assisted, and as they gathered to stitch, they shared the stories of their lives, like so many others have done in sewing bees and quilting circles over the years.

In many ways, then, the blanket pieces pay quiet homage to important craft traditions, just as the cedar base and stacked blankets in *Three Sisters* gracefully acknowledge the linen closets and cedar chests of the private, domestic sphere. But Marie's work also enters into dialogue with avant-garde art traditions. Bold compositions of concentric circles reference the *Targets* of Jasper Johns, for example—another artist who is also interested in slowing down the act of looking and paying attention to those overlooked corners of visual culture. Similarly, Watt's blanket columns vigorously engage the history of sculpture, from Brancusi's *Endless Column* and Robert Morris's antiform pieces made of industrial felt to the robed and blanketed performances of Josef Beuys. And,

too, Watt's blanket pieces enter into a kind of call-and-response with Robert Rauschenberg's *Bed* as they occupy the same liminal space between art and life.

All of these rich associations and influences are evident in the careful, precise prints (figs. 59, 60) Marie Watt made at Tamarind. The woven texture of wool, the concentric circles and bands of contrasting color, the meandering trail of linked diamond shapes, and the patchwork quilt designs are imprinted on successive plates and on separate, overlapping sheets of fine paper like so many blankets on a bed. Even the torn, tattered edges of a coverlet find their equivalent in these prints in the soft, torn edges of the Japanese paper *chine collé*. Yet these relationships, like her palette, remain subtle and suggestive.

And the associations do not end there. All of Watt's patterns and motifs have the possibility of infinite extension *across* the field of the print. Like cells that divide and multiply, or ripples that spread across a pool of water from a single drop of rain, the sense of rootedness in multiple traditions is held in delicate tension with the possibility of growth and transformation. As with all the prints in *Migrations*, culture is indeed migration as well as rooting. And happily so.

All six of the artists selected for the *Migrations* project are pursuing distinct—and distinctly different—directions in their art. There are, to be sure, common points of reference. Private, individual preoccupations intersect and fuse with specific cultural traditions and more broadly shared concerns in artworks that are both timely and contemporary. The *Migrations* suite of prints draws attention to these similarities and differences. Through their commitment to artistic collaboration and the medium of print, Tamarind and Crow's Shadow provide sites for artists to connect and for ideas to circulate. The *Migrations* project celebrates and ensures the survival of culture and expands the possibilities for individual creative expression. ᔕ

# Notes

1. Eleanor Heartney, "The Well-Tempered Biennial," *Art in America* (June/July 2004): 71. The curators of the 2004 *Whitney Biennial* included Chrissie Iles, Shamim Momin, and Debra Singer.

2. The exhibit, for which there is a published catalog with the same title, was on view at the Museum of Contemporary Art, Chicago, from February 12 through June 5, 2005.

3. I would like to thank Marjorie Devon and the entire staff at Tamarind for the invaluable assistance and gracious hospitality they extended as I began work on this project. The institutional commitment to collaboration and exchange is widely and genuinely shared by the entire Tamarind community.

4. James Clifford, "Of Other Peoples: Beyond the 'Salvage' Paradigm," in *Discussions in Contemporary Culture, Number One*, ed. Hal Foster (Seattle, WA: Bay Press, 1987), 126.

5. Formerly known as the Winnebago, in 1994 the tribe officially changed their name to Ho-Chunk Sovereign Nation, to reflect their own word for themselves.

6. Jones is also working on his MA in Museum Studies at Columbia College.

7. Tom Jones, as quoted by Melanie Herzog in an unpublished essay, "'Dancing in Two Worlds':

Strategies of Representation in the Work of Ho-Chunk Photographer Tom Jones," ca. 2004.

8. Lucy Lippard, unpublished essay, "Like a Feather in the Air," ca. 1999.

9. Robert Cozzolino, "Group Portrait: A Radiant Photo Show Captures the Ho-Chunk Spirit," *Isthmus* (April 6, 2001): 23.

10. Artist's Statement submitted with *Migrations* application.

11. Ruth B. Phillips, *Trading Identities; The Souvenir in Native North American Art from the Northeast, 1700–1900* (Seattle: University of Washington Press and McGill-Queen's University Press, 1998), 6.

12. For a cogent history of recent attitudes toward fine art prints, see Deborah Wye, *Thinking Print: Books to Billboards, 1980–95* (New York: Museum of Modern Art, 1996).

13. Tom Jones, personal communication, 9 February 2005. Every feature in the print carries symbolism. For example, the Woodland border design symbolizes the close indigenous connection to nature and a more natural diet that was lost to the heavily processed foods Native Americans were subsequently given. Jones enfolded a heart shape into the design, another reference to health and well-being.

14. Although health issues are not his primary concern, John Hitchcock is another artist who has for several years featured food commodities prominently in his prints and installations.

15. For the *Venice Biennale* 2005, Luna is preparing *Emendatio*, a new, more elaborate performance that, among other topics, addresses

the declining health of indigenous populations everywhere.

16. Star Wallowing Bull, personal communication, 26 February 2005.

17. Artist's Statement submitted with *Migrations* application.

18. This and all subsequent quotes by Star Wallowing Bull are from personal communication, 26 February 2005 and 10 March 2005.

19. Star Wallowing Bull as quoted by Todd Bockley in his nomination letter of the artist for inclusion in the *Migrations* project.

20. Clear traces of Frank Big Bear (born 1953), the artist's father, are also readily found in Wallowing Bull's aesthetic and his imagery. Additionally, Wallowing Bull regularly includes references to the art of Ojibwe artist George Morrison (1919–2000), with whom Star's father studied and enjoyed a close friendship, and whose art Star greatly admires and respects.

21. Todd Bockley, nomination letter.

22. In fact, the accumulation (or proliferation) of an impressive array of styles and systems of representation is a hallmark of Wallowing Bull's drawings.

23. Other recent drawings show an increasing affinity to the art of fellow Ojibwe Norval Morrisseau (born 1931), who established the so-called Woodland style.

24. Steven Deo, interview with the author, 17 December 2004. This and all subsequent quotes by Steven Deo are from this interview.

25. Artist's biography submitted with *Migrations* application.

26. This and all subsequent quotes by Larry McNeil are from personal communication, 7 March 2005.

27. Nigel Russell, "Processes and Pictures: The Beginnings of Photography and of Photographing American Indians," in *Spirit Capture: Photographs from the National Museum of the American Indian*, ed. Tim Johnson (Washington and London: Smithsonian Institution, 1998), 131. According to Larry McNeil, who has been conducting research on Curtis, the photographs were made from 1904 through the late 1920s.

28. Kathleen Hauser, "Edward S. Curtis's Nostalgic Vanishing of the American Indian," in *Staging the Indian: The Politics of Representation*, ed. Jill D. Sweet (Saratoga Springs, NY: The Tang Teaching Museum and Art Gallery at Skidmore College, 2001), 31.

29. N. Scott Momaday, quoted in Gerald Vizenor, "Trickster Discourse: Comic and Tragic Themes in Native American Literature," in *Buried Roots and Indestructible Seeds*, ed. Mark A. Lindquist and Martin Zanger (Madison: University of Wisconsin Press, 1995), 67.

30. McNeil's interpretation of the real meaning of Curtis's project is encapsulated in the small, pale skull that floats in the background.

31. For information on the importance of story and the intertwining of story with visual art in Tlingit culture, see Janet C. Berlo and Ruth B. Phillips, *Native North American Art* (Oxford and New York: Oxford University Press, 1998).

32. Larry McNeil, personal communication, 7 March 2005.

33.  Quote is from McNeil's "Statement about Work," submitted with Tamarind application. In a personal communication, McNeil told me that he spent a couple of years being raised by his grandmother, a leader in her Tlingit community and mother of the chief of the Kéet Hít, or Killer Whale clan house at Klukwan, Alaska.

34.  Berlo and Phillips, *Native North American Art*, 175.

35.  David W. Penney, *North American Indian Art* (New York and London: Thames and Hudson, 2004), 146.

36.  Ibid.

37.  Artist's Statement, 2003, 11.

38.  It is the humor that is most conspicuous in McNeil's *Migrations* prints. Both are funny. Each one carries multiple jokes and jabs. Satire travels in every direction. Much has been written about Indian humor, and the ways in which Native artists use humor to address critical concerns. For his part, Larry McNeil attributes his own sardonic wit to a distinctly Tlingit, or Northwest Coast, worldview. He contends that anthropologists have failed to recognize the centrality of irony and satire in the sensibility of Northwest Coast peoples. He explains that in Tlingit culture, even the most serious stories poke fun at someone or something and oftentimes, many things at once; no one is immune. His *Migrations* prints operate in a similar manner. "The sense of satire is a continuation of stuff that's been going on for thousands of years," McNeil tells me.

39.  Unless otherwise noted, this and all subsequent quotes by Ryan Lee Smith are drawn from his Artist's Statement, e-mailed to Marjorie Devon, 24 August 2004.

40.  Ryan Lee Smith, biographical information e-mailed to Marjorie Devon, 13 November 2004.

41.  Michael Dorris, "Indians on the Shelf," in *The American Indian and the Problem of History*, ed. Calvin Martin (New York and Oxford: Oxford University Press, 1987), 100.

42.  Susan Sontag, *Against Interpretation* (New York: Farrar, Giroux and Straus, 1966), 10.

43.  A Boeing engineer before his retirement, her father is clearly also an important influence in her life.

44.  Inara Verzemnieks, "Blanket Coverage," *The Sunday Oregonian*, 8 August 2004.

45.  Marie Watt, "Artist's Statement," in *Marie Watt. Blanket Stories: Receiving* exhibition brochure (Portland, OR: Ronna and Eric Hoffman Gallery of Contemporary Art, Lewis and Clark College, 2005), 8.

46.  Marie Watt, as quoted in Lara M. Evans, "Marie Watt: A Blanketed Space," in *Continuum: 12 Artists* exhibition brochure (New York: National Museum of the American Indian, Smithsonian Institution, George Gustav Heye Center, 2004), 2.

47.  Watt, *Blanket Stories*, 8.

48.  In her Artist's Statement, Watt writes, "In some ways, I see the blanket column as a ladder for Sky Woman, linking earth with the universe" (*Blanket Stories*, 8).

49.  Truman Lowe, quoted in Inara Verzemnieks, "Blanket Coverage."

# PART TWO: Artists

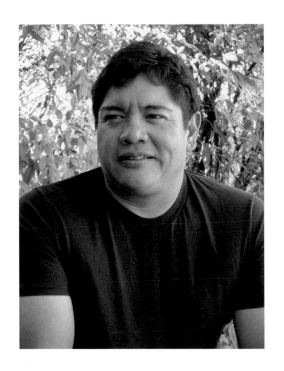

# Steven Deo

Born in Claremore, Oklahoma, 1956; lives
in New Mexico.

Member of the Creek Nation, Euchee Tribe.

Studied at Institute of American Indian
Arts, Santa Fe, New Mexico (AFA in
Three-Dimensional Art, 1991; AFA in Two-
Dimensional Art, 1992); San Francisco Art
Institute (BFA, 1994); Purdue University,
West Lafayette, Indiana; and University of
Oklahoma, Norman.

## Selected Exhibitions

*Migrations: New Directions in Native American Art.* University of New Mexico Art Museum,
  Albuquerque (2006); traveling under the auspices of TREX, Museum of New Mexico (2007–).

*Room for Thought* (solo show). Institute of American Indian Arts, Santa Fe, New Mexico (2005).

*Rolling Thunder.* Foothills Art Center, Golden, Colorado (2005).

*Steven Deo* (solo show). Lois Lambert Gallery, Santa Monica, California (2005).

*Perceptions* (solo show). Center for Contemporary Arts, Santa Fe, New Mexico (2004).

*Insight Out.* Center for Contemporary Arts, Santa Fe, New Mexico (2004).

*What You See Is Who I Am.* Visiones Gallery (Working Classroom), Albuquerque, New Mexico (2004).

*Biennale Internazionale Dell'Arte Contemporanea.* Fortezza da Basso, Florence, Italy, award (2003).

*Mark My Words: Text in Visual Art.* Magnifico, Albuquerque, New Mexico (2003).

*Four in One.* American Indian Community House, New York (2003).

*Common Ground.* Tucson Museum of Art, Arizona (2003).

*Inspirations.* Museum of Indian Arts & Culture, Santa Fe, New Mexico (2002).

*Art Facts.* George Eastman House Museum of International Film & Photography, Rochester,
  New York (2002).

*who stole the tee pee?* Institute of American Indian Arts Museum, Santa Fe, New Mexico (2002)
  George Gustav Heye Center, National Museum of the American Indian,
  Smithsonian Institution, New York (2001); Heard Museum, Phoenix, Arizona (2001).

*Open Studio Exhibition.* The Trent Building, Irvington, New York (2001).

*Odyssey.* Sam Noble Museum of Natural History, University of Oklahoma, Norman (2001).

*Kingston Biennial Sculpture Exhibition.* Kingston, New York (1999).

*Gifts of the Spirit.* Eiteljorg Museum, Indianapolis, Indiana (1998).

*Indian Humor.* George Gustav Heye Center, National Museum of the American Indian,
  Smithsonian Institution, New York (1998).

As a contemporary artist of Native American descent, identity has been a constant point of reference. Often, I've looked into the past through the eyes of the camera at images of my family, or at images reproduced in Western histories. Then, nature was our environment: we looked to the sky and made kinship with the stars, the moon, and the sun. The earth lived under our bare feet and rivers flowed through our bodies and minds. Our environment has changed and our "nature" replaced with concrete, steel, and asphalt. We have been relocated and dislocated, grouped and regrouped. Our communality is an extended family called "Indian."

Although I grew up in an urban environment in Tulsa, Oklahoma, . . . I had other experiences that centered on native religion and ceremony that were very much part of the fiber of my life.

For as long as I can remember, I was sent to stay with my paternal grandparents, who had retired on land that was our Indian allotment. They owned a television, but the reception was not very good, so at night Grandma Deo would teach me the language, tell us stories. During the days, I would ride their old plow horse, day in and day out.

I also had a relationship with my mother's family. Her mother was a full blood Creek Indian, and her father a full blood Euchee. He was a hereditary chief, a Bear Clan member. When I was very small, I would sit next to him during our dances. They would begin at midnight and last until sunrise, and I would often fall asleep and wake up in his pickup truck. Whenever I can, I still participate in the Greencorn ceremony during the summer solstice, dancing and taking medicine all day.

I continually think about the people I came from, although the language they spoke becomes clouded by time and daily life. The songs from the beginning of creation resonate in my daydreams, and I find solace in that sacred place called art. ✑

---

14. Steven Deo
    *Perpetual Stream*, 2004.
    Mixed media, 60 x 21 x 14 in. (large figure).
    (Photo: Pat Berrett)

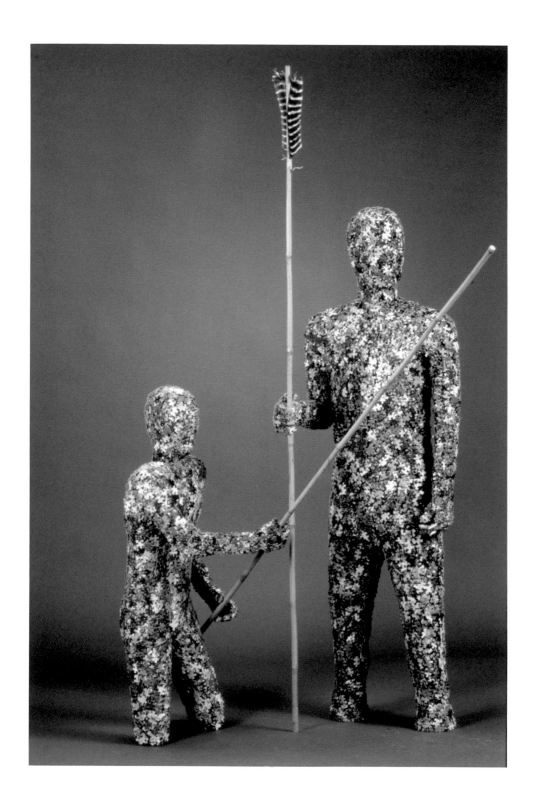

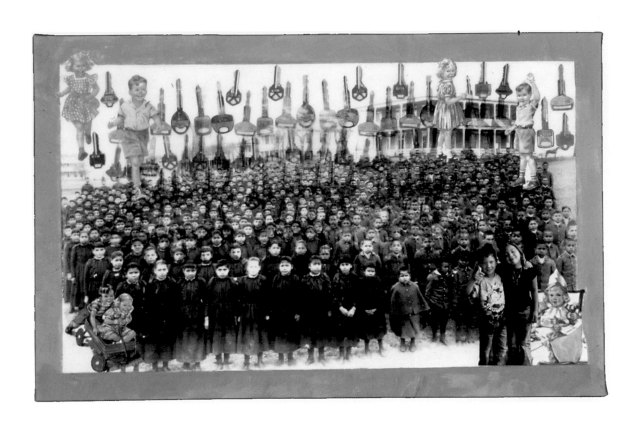

15. Steven Deo
*When We Become Our Role Models*, 2004.
Mixed media, 20½ x 32 in.
(Photo: Pat Berrett)

16. Steven Deo
*Rulers*, 2004.
Mixed media, 29 x 16 x 16 in. (large figure).
(Photo: Pat Berrett)

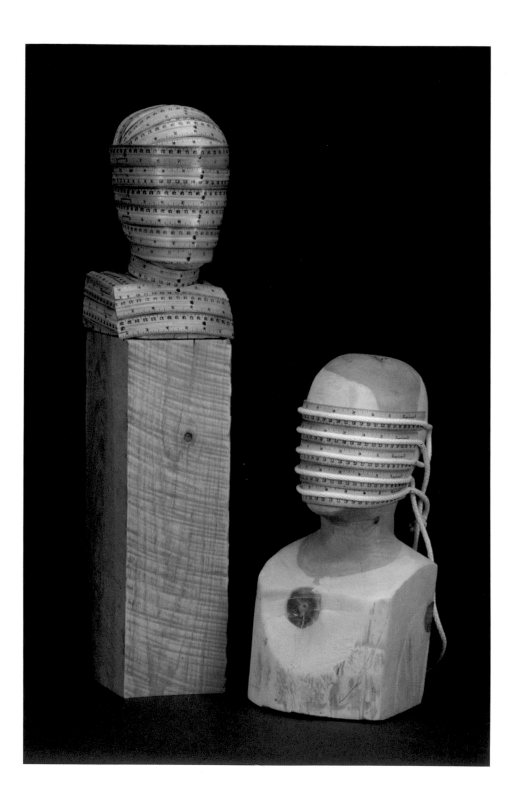

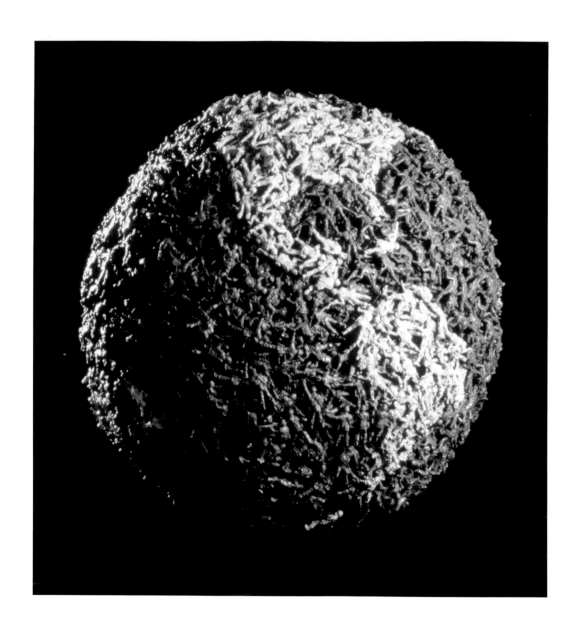

17. Steven Deo
*Global War*, 2005.
Mixed media, 26 in. diameter

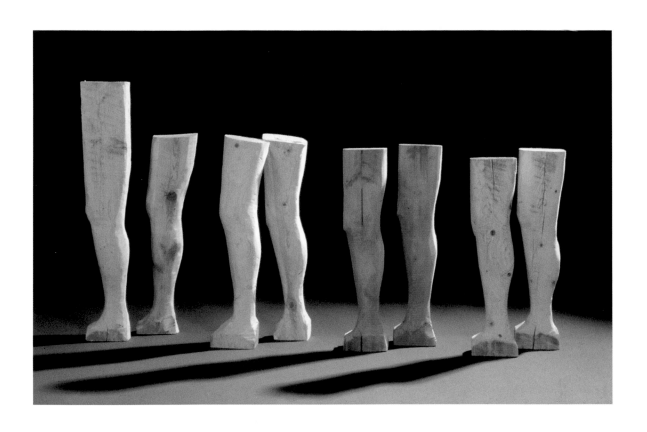

18. Steven Deo
*Dance of the Woods* (detail), 2005.
Installation, pine, tallest leg, 4 x 6 x 33 in.
(Photo: Pat Berrett)

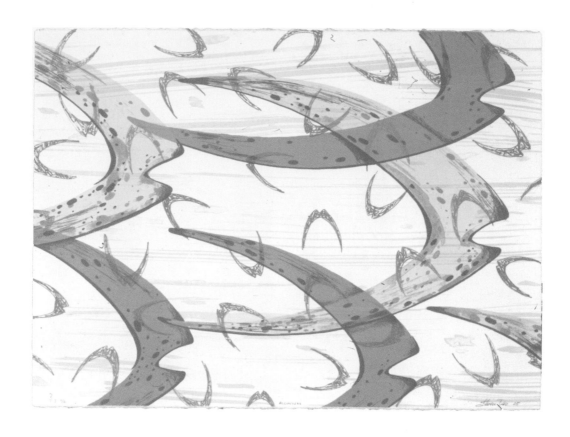

19. Steven Deo
    *Alluvium*, 2004.
    Lithograph, 22½ x 30 in.
    Collaborating printer, Frank Janzen;
    Printed by Jim Teskey.
    (Photo: Margot Geist)

Within the image:
1. $a < a$. (Principle of identity).
2. If and only if $a < b$ and $b < a$, then $a = b$.
3. If $a < b$ and $b < c$, then $a < c$. (Principle the syllogism; see also theorems 22 and 23, ow).
4. $a + a = a$ and $aa = a$. (Tautology)
5. $a + ab = $ d $a(a + b) = a$. (sorption)

PRINCIPLE of IDENTITY

20. Steven Deo
*Principle of Identity*, 2004.
Lithograph, 22½ x 30 in.
Printed by Deborah Chaney.
(Photo: Margot Geist)

# Tom Jones

Born in Charlotte, North Carolina, 1964;
lives in Wisconsin.

Member of the Ho-Chunk Nation.

Studied at University of Wisconsin,
Madison; School of Visual Arts, New York;
Columbia College, Chicago, Illinois (MA,
Museum Studies, 2002; MFA, Photography,
2002).

## Selected Exhibitions

*Migrations: New Directions in Native American Art*. University of New Mexico Art Museum, Albuquerque (2006); traveling under the auspices of TREX, Museum of New Mexico (2007–).

*The Ho-Chunk People* (solo show). Buffalo Arts Studio, New York (2004); Rochester Art Center, Minnesota (2001); Pump House Regional Art Center, La Crosse, Wisconsin (2001); Wisconsin Cultural Center, Wisconsin Rapids (2001); Wendy Cooper Gallery, Madison, Wisconsin (2001).

*Our Lives: Contemporary Life and Identities*. National Museum of the American Indian, Washington DC (2004).

*Honoring the Ho-Chunk Warrior* (solo show). Michigan State University, East Lansing (2004); Wisconsin Veterans Museum, Madison (2003).

*Choka* (solo show). De Ricci Gallery, Edgewood College, Madison, Wisconsin (2003).

*America—First People, New People, Forgotten People*. Blue Sky Gallery, Portland, Oregon (2003); Moser Gallery, University of St. Francis, Joliet, Illinois (2003).

*The WISCONSIN Landscape*. Foster Gallery, University of Wisconsin, Eau Claire (2003).

*Albert P. Weisman Memorial Scholarship Show*. Hokin Gallery, Chicago (2002, 2003).

*Multiple Voices*. Kings Foot Gallery, Madison, Wisconsin (2002).

*Group Show*. Sherry Leedy Contemporary Art, Kansas City, Missouri (2002).

*Wisconsin Triennial*. Madison Art Center, Wisconsin (2002).

*Still Lifes*. Michael Lord Gallery, Milwaukee, Wisconsin (2002).

*Wank Sheek Ka Day/The Big People* (solo show). H. H. Bennett Studio, Wisconsin State Historical Society, Dells (2000).

*Objects Transformed*. Wendy Cooper Gallery, Madison, Wisconsin (2000).

*The Unfolding* (solo show). A Space Gallery, Madison, Wisconsin (1988).

*Recent Work from Dane County*. Madison Art Center, Wisconsin (1988).

*Still Movements* (solo show). Memorial Union Galleries, Madison, Wisconsin (1987).

I feel a responsibility to portray the Native American experience, and the contributions to the history of the United States of Native peoples, who have been largely without a voice in the documentation of this history. For years, I have been collecting photographic postcards from the turn of the last century. In my research, I came across an image of a beautiful Native American woman with a child strapped to her back. Underneath the image was the caption, "The White Man's Burden." This image has remained with me, and was the catalyst for the series of images entitled "Dear America," which ironically juxtapose the lines from the song *America* with classic images from these postcards.

Typically, photographs of the Native American Indian were taken by outsiders. We have generally been represented with beads and feathers, widely known through the extraordinary photographic portrayals of Edward Curtis. Like many Native American Indians, the Ho-Chunk people still adhere to traditional ways even as they have adapted to the white culture that surrounds them. The emphasis of my photographic work is on the members of my tribe and the environments in which they live, giving a name and face to the individuals and their way of life in our own time. First and foremost, I am mindful of my responsibility to the tribe to help carry on a sense of pride about who and what we are as a people. I want the public to see the strength and resilience of the Ho-Chunk people.

Everything Ho-Chunks do in their traditional life is a form of art. We have an eye for detail; we are taught as children to observe and to pay close attention to everything around us. We are also asked, "What are you going to do to improve the life of others?" Upon the passing of my grandfather, I was asked to take his place in the Medicine Lodge. I have chosen to follow in his footsteps to carry on the traditional ways of our people; and I followed in my father's footsteps in photography, creating a visual archive for future generations. ✍

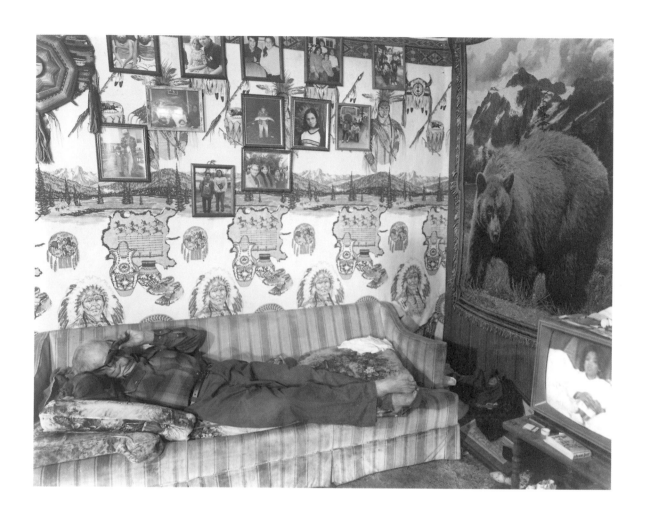

22. Tom Jones
*Choka Watching Oprah/Jim Funmaker.*
*(The Ho-Chunk People Series)*, 1998.
Silver gelatin print, 20 x 24 in.

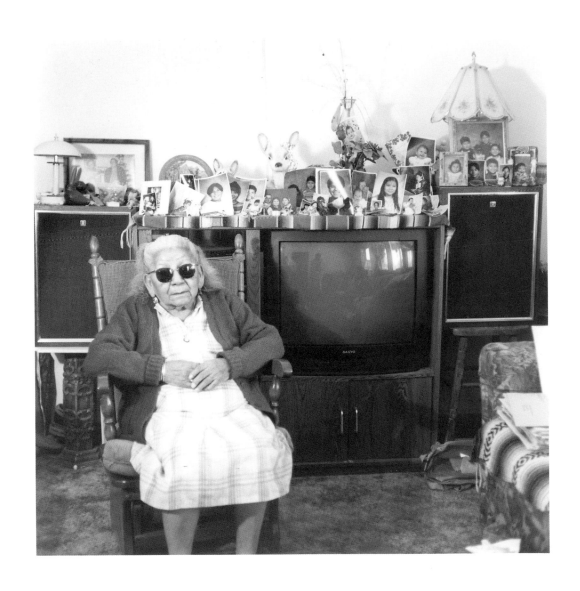

23. Tom Jones

*Nina Cleveland.*

*(The Ho-Chunk People Series)*, 1998.

Silver gelatin print, 18 x 18 in.

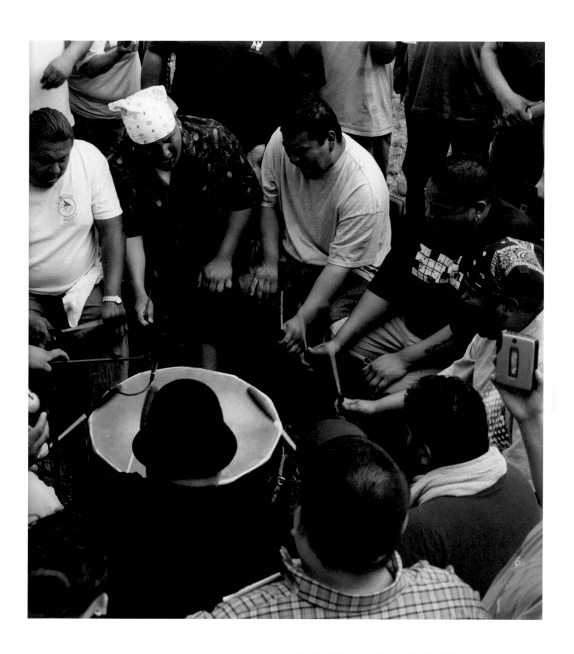

24. Tom Jones
    *Drummers.*
    *(Honoring the Ho-Chunk Warriors Series)*, 2003.
    C-print, 28 x 36 in.

My Country 'tis of thee

© L.L. COOK CO.

THESE COLORS WILL NOT RUN

25. Tom Jones
*My Country 'tis of Thee.*
*(Dear America Series)*, 2002.
Digital inkjet print, 22 x 36 in.

The hanging of 38 Sioux and Ho Chunk men took place just south of Mankato, Minnesota, near the current Holiday Inn and Minnesota Valley Regional Library. The United States government under the leadership of Abraham Lincoln ordered the largest mass execution in

SWEET LAND OF LIBERTY

North American history, the day after Christmas 1862.

26. Tom Jones
*Sweet Land of Liberty.*
*(Dear America Series)*, 2002.
Digital inkjet print, 36 x 24 in.

27. Tom Jones
    *Commodity I*, 2004.
    Lithograph, 30 x 22 in.
    Printed by Deborah Chaney.
    (Photo: Margot Geist)

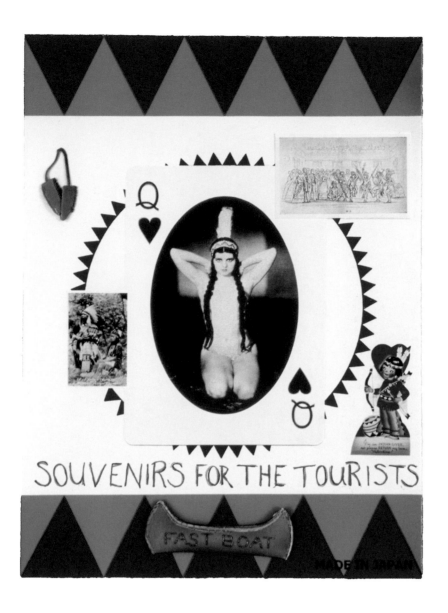

28.  Tom Jones
     *Commodity II*, 2004.
     Lithograph, 30 x 22 in.
     Printed by Jim Teskey.
     (Photo: Margot Geist)

Photo: T'naa Zakeesh McNeil

## Larry McNeil

Born in Juneau, Alaska, 1955; lives in Idaho.

Member of Tlingit and Nisga'a nations.

Studied at Brooks Institute, School of Photographic Art and Science, Santa Barbara, California (BA, Photographic Illustration, 1978); Institute of American Indian Arts, Santa Fe, New Mexico (1995–96); University of New Mexico (MFA, Photography, 1999).

Photography Instructor, Institute of American Indian Arts, Santa Fe, New Mexico (1992–96).

Associate Professor of Photography, Boise State University, Idaho (1999–present).

## Selected Exhibitions

---

*Migrations: New Directions in Native American Art.* University of New Mexico Art Museum, Albuquerque (2006); traveling under the auspices of TREX, Museum of New Mexico (2007–).

*From Earth to Cyberspace: Contemporary Native American Clay and Digital Works* (Lillian Pitt, Larry McNeil, and Jim Jackson). Longhouse Cultural Center at The Evergreen State College, Olympia, Washington (2005).

*Only Skin Deep: Changing Visions of the American Self.* Organized by International Center of Photography, New York; International Center of Photography Web site (2003); Seattle Art Museum, Washington (2004).

*Hitéemkiliksix (Within the Circle of the Rim).* Organized by the Longhouse Cultural Center at The Evergreen State College, Olympia, Washington; Rotorua Museum, Rotorua City, New Zealand (2004); Tamástslikt Cultural Institute, Umatilla Reservation, Pendleton, Oregon (2003); Squaxin Island Museum and Cultural Center, Native Peoples of Puget Sound, southern Washington (2003); Longhouse Cultural Center at The Evergreen State College, Olympia, Washington (2001).

*Dog Head Stew.* Institute of American Indian Arts Museum, Santa Fe, New Mexico (2003); Paul Mesaros Gallery, West Virginia University, Morgantown (2003); Massachusetts College of Art, Boston (2003); Regis Arts Center, University of Minnesota, Minneapolis (2003).

*New Works Award Show.* Godwin-Ternbach Museum, Queens College, New York (2002).

*fly by night mythology* (solo show). Native Indian Inuit Photographers Association Gallery, Hamilton, Ontario, Canada (2001).

*Spirit Capture.* National Museum of the American Indian, Smithsonian Institution, New York (2001).

*Gathering of Indigenous Artists.* Longhouse Cultural Center at The Evergreen State College, Olympia, Washington (2001).

*Faculty Exhibition.* Boise State University Art Department, Idaho (2001).

*Raven's Reprise.* Museum of Anthropology, University of British Columbia, Canada (2000–1).

*alt.shift.control: Musings on Digital Identity*. Art Gallery of Hamilton, Ontario, Canada (2000).

*Aperture Exhibition: Strong Hearts*. Museum of Indian Arts and Culture, Museum of New Mexico, Santa Fe (2000).

*New Voices/New Visions*. Ansel Adams Center for Photography, The Friends of Photography, San Francisco, California (1999).

*Did They Rob You?* Institute of American Indian Arts Museum, Santa Fe, New Mexico (1999).

*Native Nations: Photographic Sovereignty*. Barbican Art Gallery, London, England (1999).

*The Haida Project* (solo show). C. N. Gorman Museum, University of California, Davis (1999).

My place in our American culture is a bit off-center because I, like many other Native Americans, really grew up outside of the mainstream while simultaneously being immersed in it, which is a kind of paradox that confuses the hell out of everyone, me included. As a kid I was likely to hear Roy Orbison blasting *Pretty Woman* out of the jukeboxes in bars along the avenue, and then go home to traditionally smoked salmon and hearing my grandma talking to my mom in Tlingit.

Being raised partly by our grandmother, who was born in the late 1800s, gave my siblings and me an atypical worldview—and an unusual strength and deep connection to our identity. We were raised in turbulent times that challenged our very existence as Tlingit people—from experiencing racism in our everyday lives to having the government refuse claims to our traditional homeland

and our right to exist as a sovereign nation. Our experiences are not unusual . . . many of our friends and relatives have similar stories, and they continue to forge powerful bonds that go deeper than blood.

I see my work as a bridge between cultures that is satirical about both. After finding our own mythological creature, the raven, to be very relevant to the absurdities that we encounter every day in America, I drifted toward the broader idea of myths and mythology and how it informs who we are. The title of the series, *fly by night mythology*, seemed perfect for everything that I have been making work about because it refers to the Tlingit creation story in which Raven flew by night because in the beginning there was no light. The raven from the Northwest Coast is also a changeling or transformer and is a trickster. "Fly by night" is also a colloquialism that alludes to being an undependable rascal, yet Raven plays a key role in our creation story—which makes him an embodiment of irony, an aspect that the Tlingit people are keenly aware of.

I have always had an affinity for words and images. Language and stories became a part of my art without much conscious thought. The use of language is not necessarily literal; I like visual metaphors. Personally, the work is very much a visual manifestation of Tlingit culture and identity, which are comprised of both formal and informal language and stories. Someone from my own Kéet Hít (Killer Whale House) would understand the interaction of text and image without having it described to them; I believe it is very innate to us. The postmodern crowd gets it too, as do kids, which is an aspect that I really love. ❧

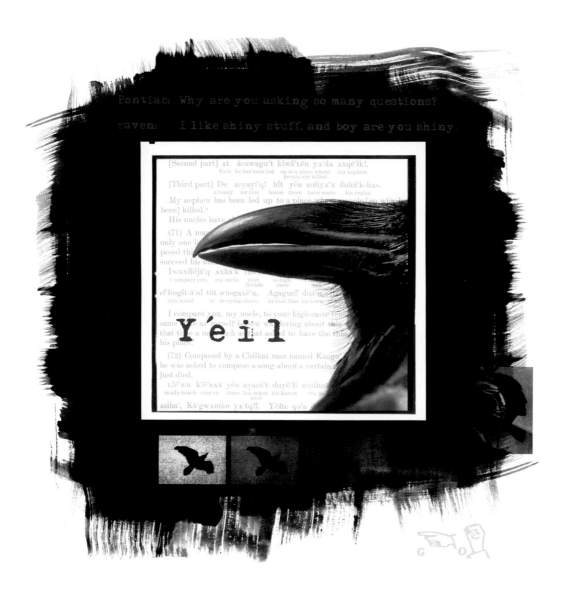

30.  Larry McNeil
     *Y'eil (Pontiac Series)*, 1998.
     Digital print, 24 x 24 in.

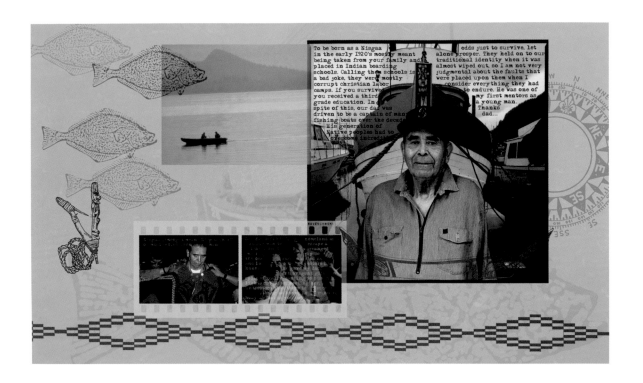

31. Larry McNeil
    *Dad*, 2002.
    Digital print, 24 x 40½ in.

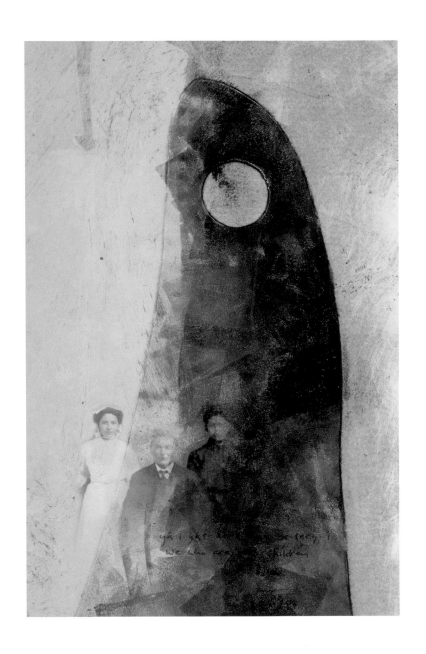

32. Larry McNeil

*Grandma, We Who Are Your Children*, 2002.

Digital print, 24 x 40½ in.

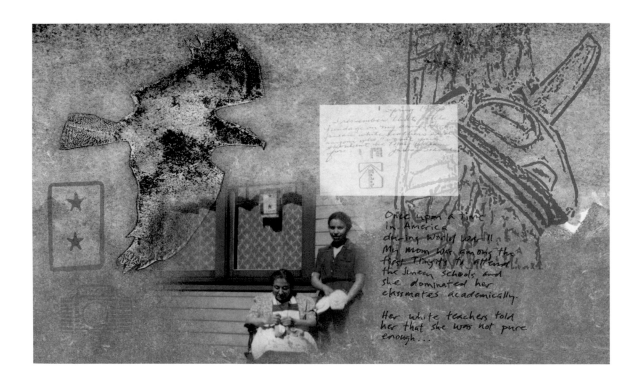

33. Larry McNeil

*Once Upon a Time in America*, 2002.

Digital print, 24 x 37 in.

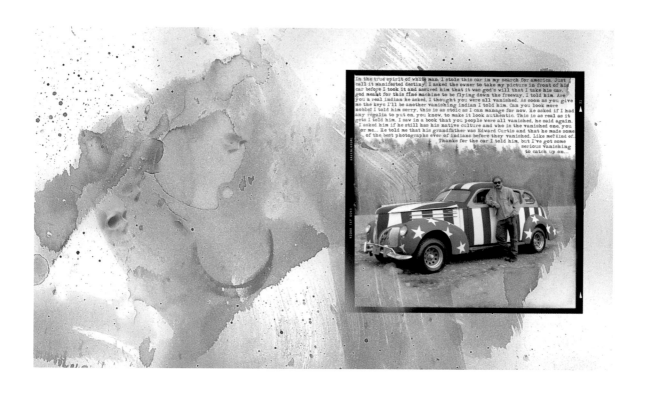

34. Larry McNeil
*In the True Spirit of White Man*, 2002.
Digital print, 24 x 40½ in.

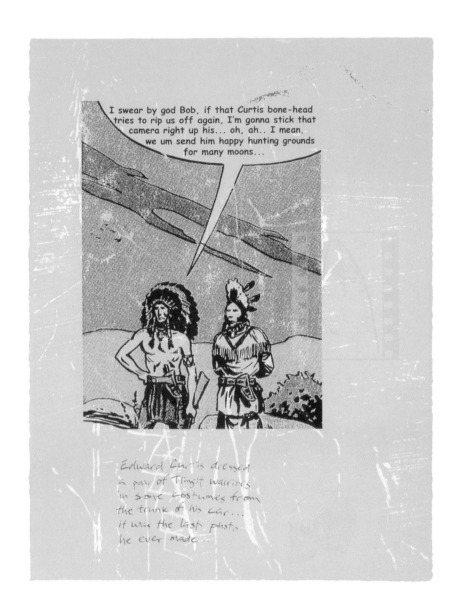

35. Larry McNeil
*Edward Curtis' Last Photograph*, 2004.
Lithograph, 36 x 28¼ in.
Printed by Frank Janzen.
(Photo: Margot Geist)

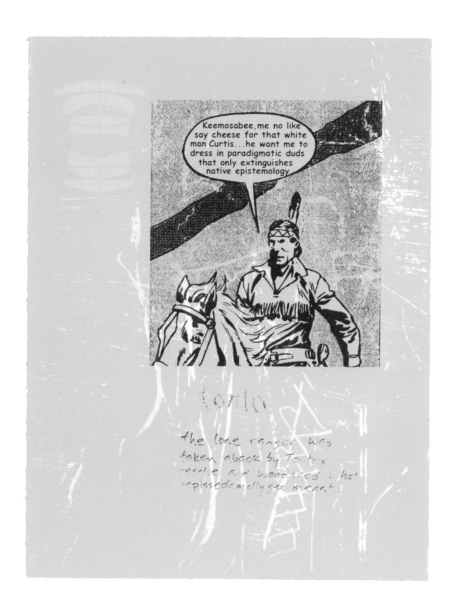

36.  Larry McNeil
     *Native Epistemology*, 2004.
     Lithograph, 30 x 22¼ in.
     Printed by Frank Janzen.
     (Photo: Margot Geist)

# Ryan Lee Smith

Born in Tahlequah, Oklahoma, 1972; lives in Oklahoma.

Member of the Cherokee Nation.

Studied at Baylor University (BFA, 1997); University of New Orleans (2004–2005).

## Selected Exhibitions

*Migrations: New Directions in Native American Art*. University of New Mexico Art Museum, Albuquerque (2006); traveling under the auspices of TREX, Museum of New Mexico (2007–).

*MFA Show*. University of New Orleans, Louisiana (2003, 2004).

*New Work*. Alpha Fine Arts, Santa Fe, New Mexico (2002).

*Group Show*. The Art Room, Durango, Colorado (1999).

*Matrix*. Waco, Texas (1997).

*Portrait of the Artist as a Young Joyce*. William Campbell Contemporary Art, Ft. Worth, Texas (1995).

As a child living in a small town in Oklahoma, my main interests were rurally based. I enjoyed setting trot lines for catfish and seining creeks for the bait. Venturing . . . far out into the country was always exciting, sometimes scary. I would walk the woods and notice everything. After high school, I went to Baylor University and worked with Karl Umlauf. There, I decided that I wanted to paint, but I lacked discipline. I moved to Durango, Colorado, in 1997, soon after graduation because I hadn't seen the mountains before. It was in Colorado that I really focused on my work— I did hundreds of drawings and paintings in the mountains. I traded or sold them for a few dollars just to make ends meet. I now regret that those paintings are not accounted for, but those five years of just exercising my abilities outside the context of contemporary art were vital to my work's evolution.

I returned to Oklahoma with my soon-to-be wife, whom I met at a wood mill where we were both working. I decided to apply to grad school in New Orleans because I wanted to live near water, but more importantly, I wanted to be back in an educational environment. I wanted to see what other artists were doing. The University of New Orleans awarded me the Marcus B. Christian Graduate Scholarship, so I went. The urban environment in New Orleans is a big influence on my work and my life. I love the accessibility of everything and am excited by the overall vibe of the city. Every time I see the streetcar or drive by the Superdome, I am proud to be here. However, as Merle Haggard says, "the roots of my raisin' run deep," and I plan to move back to Oklahoma, to the country. I would like to do something for Native arts in Oklahoma and other places. I want to erase the stereotype attached to Native American art. I want to show the art world that Native art is not solely about representation.

There is a pulse or drumbeat that Native people have inside them. I want to translate that feeling in my work. I work spontaneously, combining everyday observations with past experiences and my thoughts or concerns of the moment. I translate these with color, line, and form. I use music to set a pulse—many different rhythms and sounds occupy a single composition. I want to make real, honest, and personal art. ☙

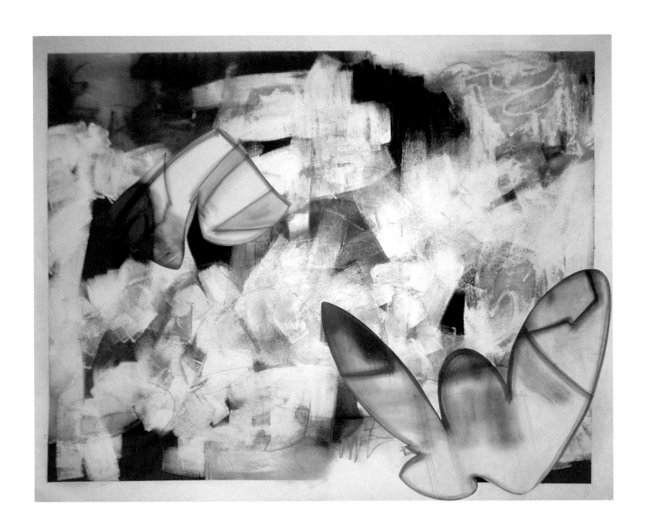

38. Ryan Lee Smith
*What*, 2004.
Mixed media on paper, 32 x 40 in.
(Photo: Meg Larned Croft)

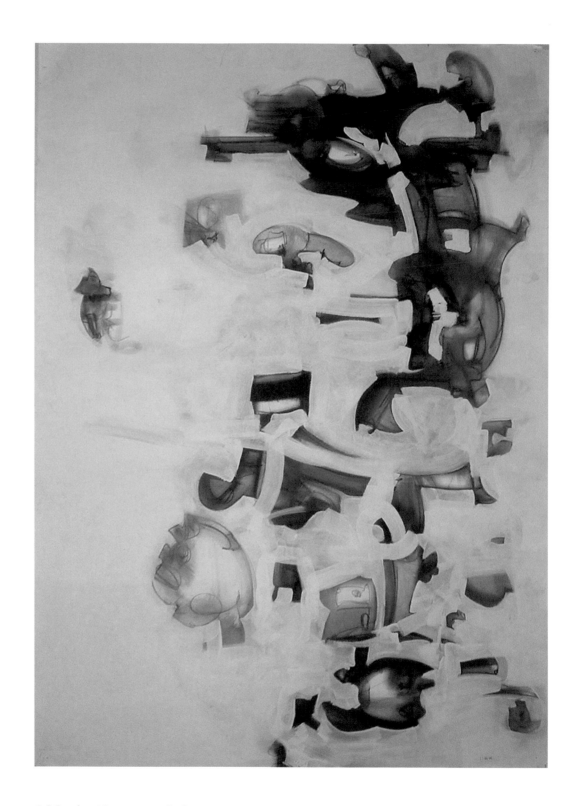

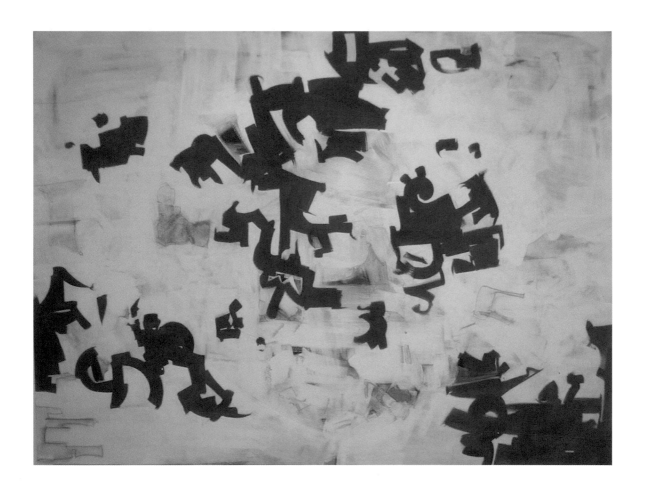

39. Ryan Lee Smith
    *Chex Mix*, 2004.
    Oil on canvas, 22 x 30 in.
    (Photo: Meg Larned Croft)

40. Ryan Lee Smith
    *Jack-o-Lantern*, 2004.
    Mixed media, 47 x 35 in.
    (Photo: Meg Larned Croft)

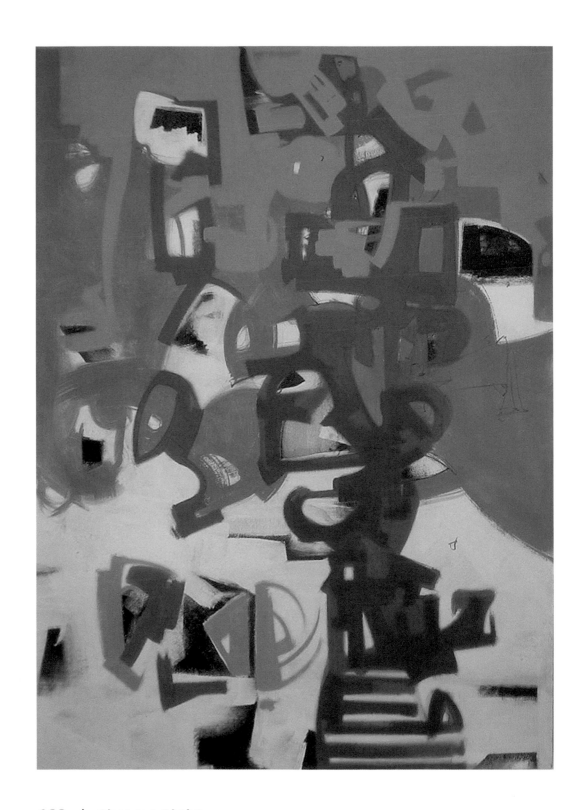

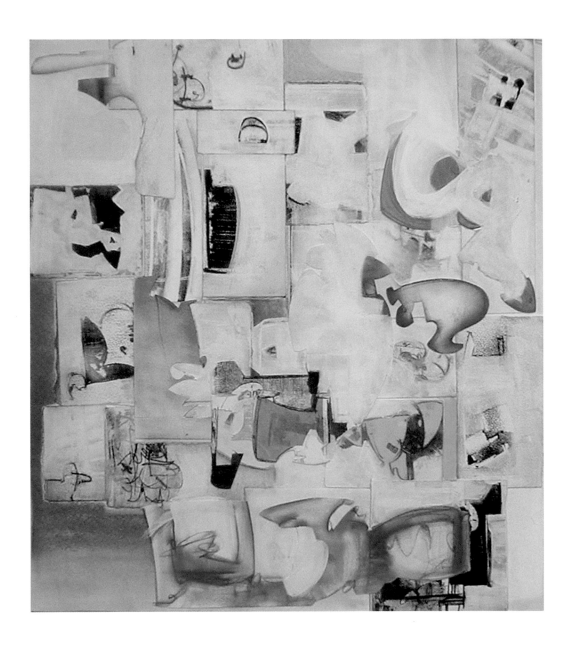

41. Ryan Lee Smith
    *Just behind That Tree*, 2004.
    Oil on canvas 32 x 50 in.
    (Photo: Meg Larned Croft)

42. Ryan Lee Smith
    *Artificial Reef*, 2005.
    Mixed media on paper, 22 x 25 in.
    (Photo: Meg Larned Croft)

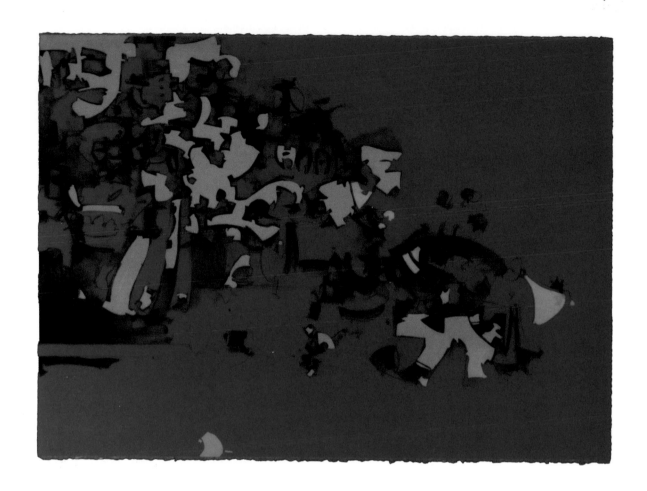

43. Ryan Lee Smith
    *Be Prepared to Stop*, 2004.
    Lithograph, 22¼ x 30 in.
    Printed by Frank Janzen.
    (Photo: Margot Geist)

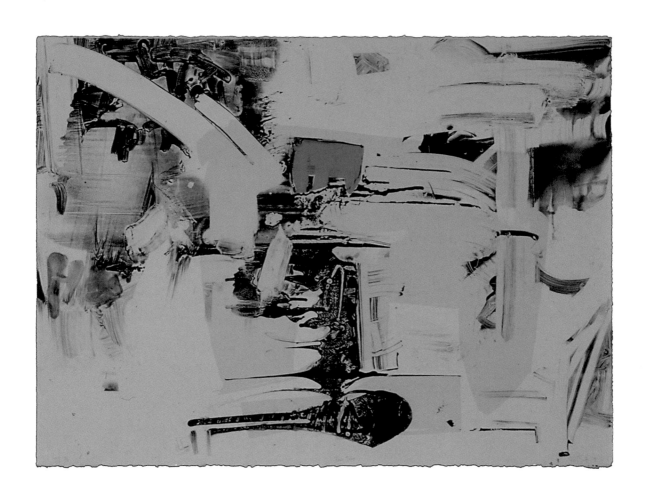

44. Ryan Lee Smith
*Bare Foot*, 2004.
Lithograph, 22¼ x 30 in.
Printed by Frank Janzen.
(Photo: Margot Geist)

# Star Wallowing Bull

Born in Minneapolis, Minnesota, 1973; lives in North Dakota.

Member of the Minnesota Chippewa Tribe, White Earth Reservation.

## Selected Exhibitions

*Migrations: New Directions in Native American Art.* University of New Mexico Art Museum, Albuquerque (2006); traveling under the auspices of TREX, Museum of New Mexico (2007–).

*From Manhattan to Menatay: The Art of Janice Toulouse Shingwaak and Star Wallowing Bull.* American Indian Community House Gallery, New York (2006).

*Between Two Cultures: The Art of Star Wallowing Bull.* Plains Art Museum, Fargo, North Dakota (2005).

*Art on the Plains.* Plains Art Museum, Fargo, North Dakota, award (2003).

*Paper Warriors: The Drawings of Frank Big Bear and Star Wallowing Bull.* C. N. Gorman Museum, University of California, Davis (2003).

*Artists at the La Fonda.* La Fonda Hotel, Santa Fe, New Mexico (2002).

*Modern Warriors: Julie Buffalohead, Star Wallowing Bull, Jim Denomie.* Texas Women's University, Denton (2002).

*Ubiquitous Visions* (solo show). Plains Art Museum, Fargo, North Dakota (2001).

*Mark Dion: Cabinet of Curiosities.* Weisman Art Museum, Minneapolis, Minnesota (2001).

*Jimisawaabandaming (Looking Ahead in a Hopeful Way).* Two Rivers Gallery, Minneapolis American Indian Center, Minnesota (2001).

*These are the People in my Neighborhood.* Bockley Gallery, Minneapolis, Minnesota (2001).

*Contemporary Native Art in Minnesota.* Weisman Art Museum, Minneapolis, Minnesota (2000).

I spent most of my life in Southside Minneapolis, until I moved to Fargo, North Dakota, in 2001. My mother is Arapaho, from the Wind River Indian Reservation in Wyoming. My father, Frank Big Bear, is an artist who is also a tribal member of the Minnesota Chippewa Tribe, White Earth Reservation. Growing up, I watched him draw and paint. I was always fascinated with his work. At a very early age, I was drawing faces and lines, and people were amazed by my unique gift. My father smiles each time he speaks of that. The greatest influence on me has been his art.

When my sister and I were reunited with my father after living with our mother in Denver for two years (I remember him crying when he saw us), he continued to encourage my artistic skills. Throughout grade school and junior high, my friends and teachers admired my work—especially my art teacher, who gave me a bag full of art supplies on the last day of school each year. He always told me I had a bright future.

My art comes out of my personal life: it is grounded in my heritage and my past. I am very attracted to bold, bright colors. Mostly I make the colors harmonize, but sometimes I use random colors that are often jarring. I am experimenting and exploring through the use of color. Like other artists today, I use imagery from advertisements and popular culture in my work. But it is from a Native American perspective, with a twist that relates the imagery to Native American ideas and issues. Although a person can enjoy my artwork without knowing anything about me or the specific piece, a deeper appreciation of the work can be gained by learning more about the images and symbols that I choose to depict.

I am on a path of self-discovery and this informs my artwork: I hope the viewers, through engagement with the work, can also learn and discover, and thus enrich themselves. Ꮼ

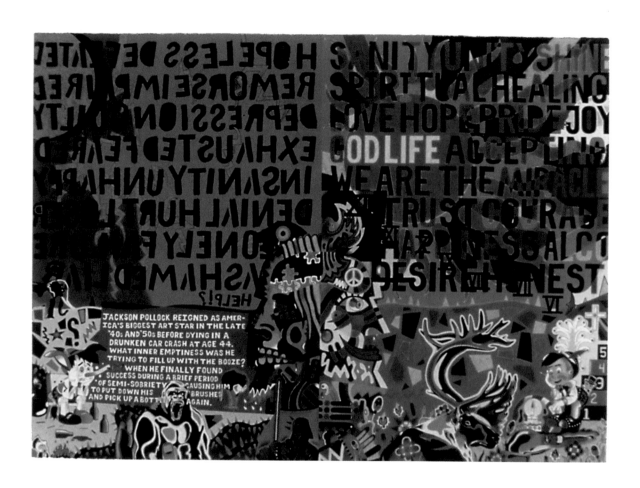

46. Star Wallowing Bull

*Mind to Mind Combat*, 2001.

Prismacolor pencil on paper, 22¼ x 30 in.

(Photo: Peter Lee, courtesy of Bockley Gallery)

47. Star Wallowing Bull

*Windigo versus the Cannibal Man*, 2002.

Prismacolor pencil on paper, 12 x 30¼ in.

(Photo: Peter Lee, courtesy of Bockley Gallery)

48. Star Wallowing Bull

*Twinkle, Twinkle Little Star, Now I Know Who You Really Are*, 2003.

Prismacolor pencil on paper, collage, 30¼ x 44 in.

(Photo: Peter Lee, courtesy of Bockley Gallery)

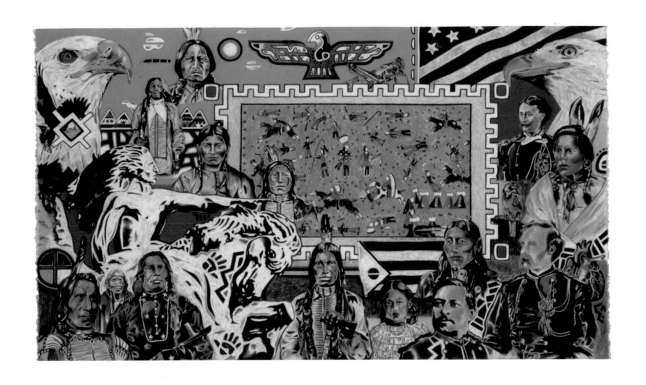

49. Star Wallowing Bull
   *Remembering 1876*, 2004.
   Lithographic crayon and Prismacolor pencil on paper, 13 x 22 in.
   (Photo: Peter Lee, courtesy of Bockley Gallery)

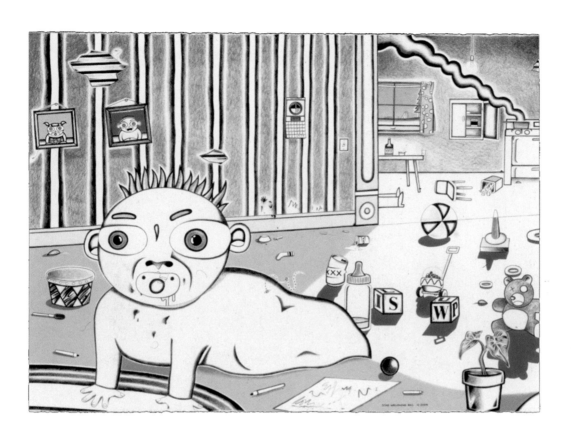

50. Star Wallowing Bull
    *The Curious Crawler*, 2004.
    Lithographic crayon and Prismacolor pencil on paper, 22¼ x 30 in.
    (Photo: Peter Lee, courtesy of Bockley Gallery)

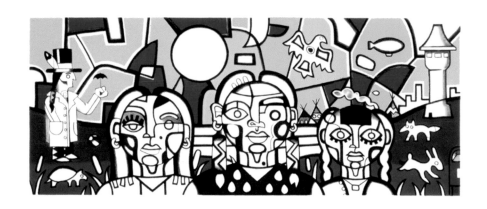

51. Star Wallowing Bull
    *My Three Sisters*, 2004.
    Lithograph, 22 x 29 in.
    Printed by Deborah Chaney.
    (Photo: Margot Geist)

52. Star Wallowing Bull
    *A Moment of Silence*, 2004.
    Lithograph, 28 x 22 5/8 in.
    Printed by Jim Teskey.
    (Photo: Margot Geist)

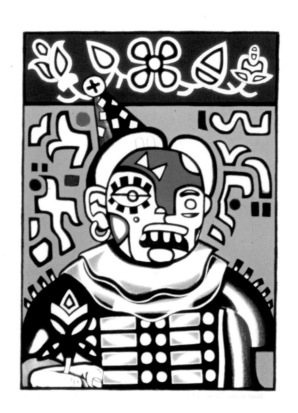

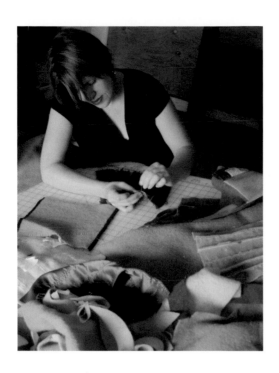

## Marie Watt

Born in Seattle, Washington, 1967; lives in Oregon.

Member of the Seneca Nation.

Studied at Willamette University, Salem, Oregon (BS, Speech, 1990); Institute of American Indian Arts, Santa Fe, New Mexico (AFA, Museum Studies, 1992); Skowhegan School of Painting and Sculpture, Maine (1995); Yale University School of Art, New Haven, Connecticut (MFA, Painting and Printmaking, 1996).

## Selected Exhibitions

---

*Migrations: New Directions in Native American Art*. University of New Mexico Art Museum,
Albuquerque (2006); traveling under the auspices of TREX, Museum of New Mexico (2007–).

*Blanket Stories: Ladder* (solo show). Institute of American Indian Arts Museum, Santa Fe,
New Mexico (2005).

*Everything is Drawing* (solo show). Hallie Ford Museum of Art, Willamette University, Salem,
Oregon (2005).

*Blanket Stories: Receiving* (solo show). Ronna and Eric Hoffman Gallery of Contemporary Art, Lewis &
Clark College, Portland, Oregon (2005).

*Continuum* (solo show). George Gustav Heye Center, National Museum of the American Indian,
Smithsonian Institution, New York (2004).

*Letter Ghosts and Recent Work* (solo show). Clatsop Community College Gallery, Astoria, Oregon (2004).

*Blanket Stories* (solo show). PDX Gallery, Portland, Oregon (2004).

*Artists Select*. Cumberland Gallery, Nashville, Tennessee (2004).

*Artists in Residence*. Oregon College of Arts and Craft, Portland (2003).

*Building Tradition*. Tacoma Art Museum, Washington (2003).

*Form to Function*. Kohler Gallery, Sheboygan, Michigan (2003).

*Stack* (solo installation). The Evergreen Galleries, The Evergreen State College, Olympia,
Washington (2003).

*Sitka Center Invitational*. Pacific Northwest College of Art, Portland, Oregon (2002).

*PDX Window Project* (solo installation). PDX Gallery, Portland, Oregon (2002).

*Governor's Gallery* (solo show). Coordinated by the Oregon Arts Commission, Salem (2002).

*Slowness*. The Art Gym, Marylhurst University, Oregon (2002).

*Inaugural Exhibition*. Open Studios Gallery, Boston (2002).

*Sleep and Sleeplessness* (solo show). PDX Gallery, Portland, Oregon (2002).

When I was in kindergarten, our teacher asked us to share something about our cultural backgrounds. I said that I was part cowboy and part Indian—my way of saying that my mom is Seneca and grew up at the Cattaraugus Reservation in upstate New York, and my dad, part German and part Scottish, grew up in a family of educators and ranchers who originally homesteaded ranchland in Wyoming. Like most children with rich imaginations and impressionable minds, I was influenced by television, particularly John Wayne Westerns. But I rooted for *both* sides. It was easy for me to ignore issues regarding identity until kids began to tease me for being different, or until I left home and suddenly questioned what "home" really was. When I went to Yale School of Art, I felt very far away from home. I tried to compensate by working with cornhusks, a material that was personally meaningful and that metaphorically represented home. The values of community and family, and a strong work ethic, were passed on to me from an early age.

My work is about social and cultural histories embedded in commonplace objects. Like Jasper Johns, I am interested in "things that the mind already knows." Unlike Pop artists, however, I use a vocabulary of natural materials (stone, cornhusks, wool, cedar) and forms (blankets, pillows, bridges) that are universal to human experience (not uniquely American) and noncommercial in nature. My approach to art making is shaped by the protofeminism of Iroquois matrilineal custom, political work by Native artists in the 1960s, a discourse on multiculturalism, as well as Abstract Expressionism and Pop Art. ↜

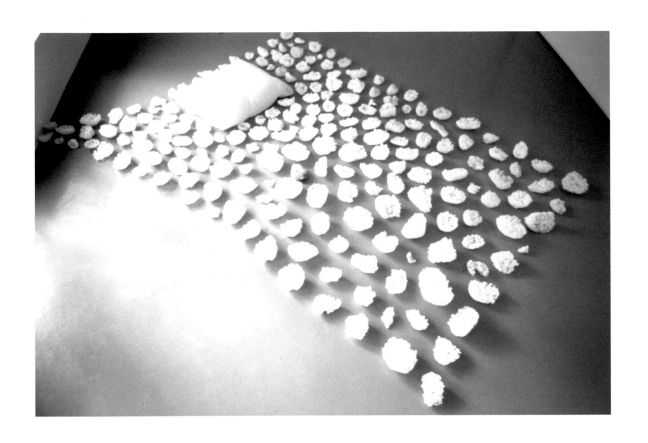

54. Marie Watt
*Blanket/Sieve*, 2002.
Translucent alabaster, 70 x 104 in.

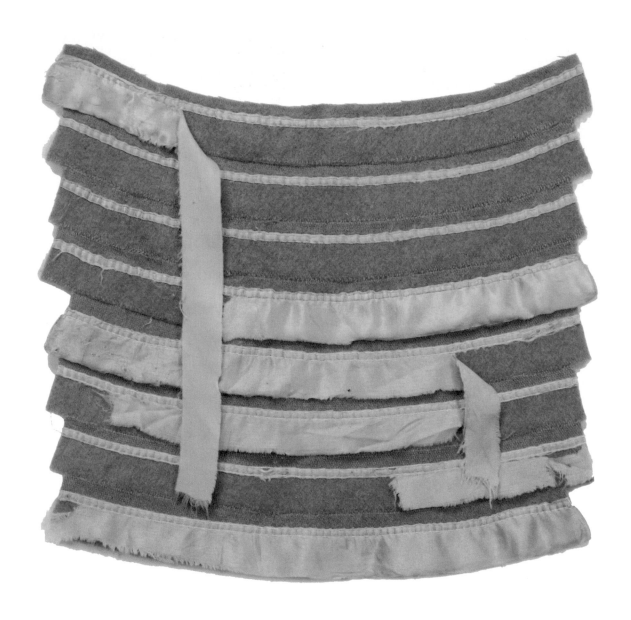

55. Marie Watt

*Ledger: Loved*, 2004.

Reclaimed wool, satin binding, 17 x 18 in.

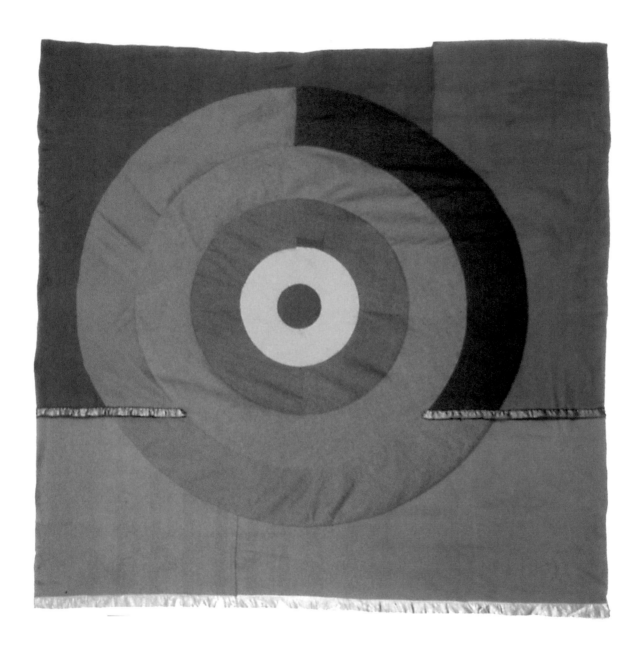

56. Marie Watt

*Flag*, 2003.

Reclaimed wool, satin binding, thread, 126 x 132 in.

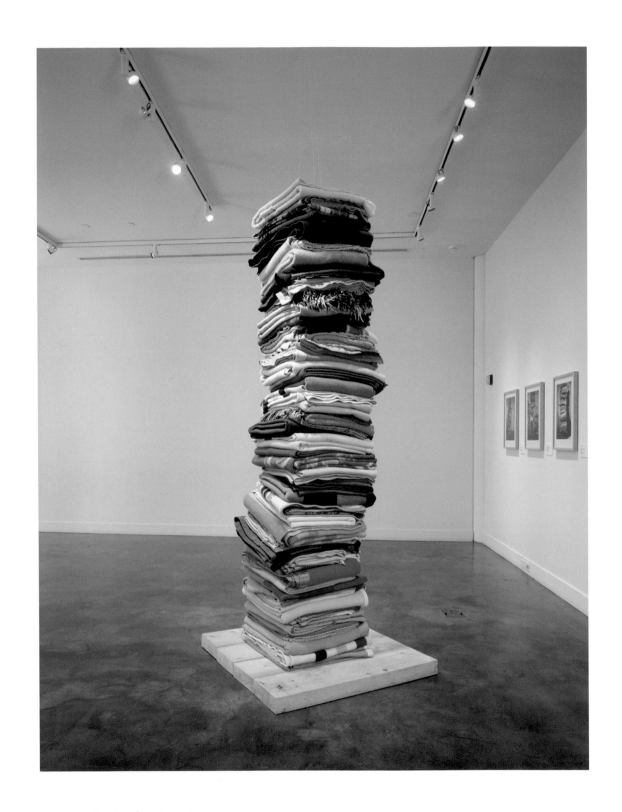

57. Marie Watt
    *Blanket Stack*, 2004.
    Wool blankets and reclaimed yellow cedar, base 3 x 12 x 40 in;
    blanket stack, 96 x 19 x 21 in.

58. Marie Watt
    *Recipe Project*, 2004, ongoing.
    Installation, wool, index cards, satin binding, each piece 4½ x 7 in.

59. Marie Watt
    *Transit*, 2004.
    Lithograph, 22 x 30 in.
    Printed by Deborah Chaney.
    (Photo: Margot Geist)

54. Marie Watt
*Receive*, 2004.
Lithograph, 17⅛ x 20⅛ in.
Printed by Jim Teskey.
(Photo: Margot Geist)

# About the Authors

## Kathleen Stewart Howe

Curator of Prints and Photographs (1994–2004) and associate director (2002–4) at the University of New Mexico Art Museum, Kathleen Howe is currently the Sarah Rempel and Herbert S. Rempel '23 Director of the Museum of Art and professor of Art History at Pomona College. She is the author of *First Seen: Portraits of the World's Peoples*, *Revealing the Holy Land: The Photographic Exploration of Palestine*, *Excursions along the Nile: The Photographic Discovery of Ancient Egypt*, and *Felix Teynard: Calotypes of Egypt, A Catalogue Raisonné*, and editor of *Intersections: Lithography, Photography, and the Traditions of Printmaking*, volume 17 of *The Tamarind Papers*.

## Lucy R. Lippard

Lucy Lippard describes herself as "a writer and activist." Lippard has authored twenty books on contemporary art and cultural criticism, including *Mixed Blessings: New Art in a Multicultural America*, *Partial Recall: Photographs of Native North Americans*, and *The Lure of the Local: Senses of Place in a Multicentered Society*. She has curated some fifty exhibitions in the United States, Europe, and Latin America, lectured widely, and serves on the boards of the Center for Constitutional Rights, Printed Matter, Franklin Furnace, and many other organizations. Lippard graduated from Smith College and New York University's Institute of Fine Arts and has received numerous honorary doctorates in fine arts, two National Endowment for the Arts grants in criticism, and a Guggenheim Fellowship, among others.

## Gerald McMaster

Gerald McMaster served as both director's special assistant and deputy assistant director for Cultural Resources at the National Museum of the American Indian in Washington DC from 2000 to 2004. Prior to this appointment he was curator of Contemporary Indian Art at the Canadian Museum of Civilization, Hull, Quebec, and adjunct research professor at the School for Studies in Art and Culture at Carleton University. Once a prominent exhibiting artist, he now concentrates on curatorial and writing projects in Aboriginal contemporary art and culture.

## Jo Ortel

After completing her undergraduate work at Smith College, and a master's degree at Oberlin College, Jo Ortel received her doctorate in Art History from Stanford University in 1992. She currently teaches Native American art at Beloit College. Dr. Ortel has curated exhibitions of work by Native artists, contributed reviews and essays to a number of publications and exhibition catalogs, and the University of Wisconsin Press published her recent book, *Truman Lowe: Woodland Reflections*.